RED ON RED

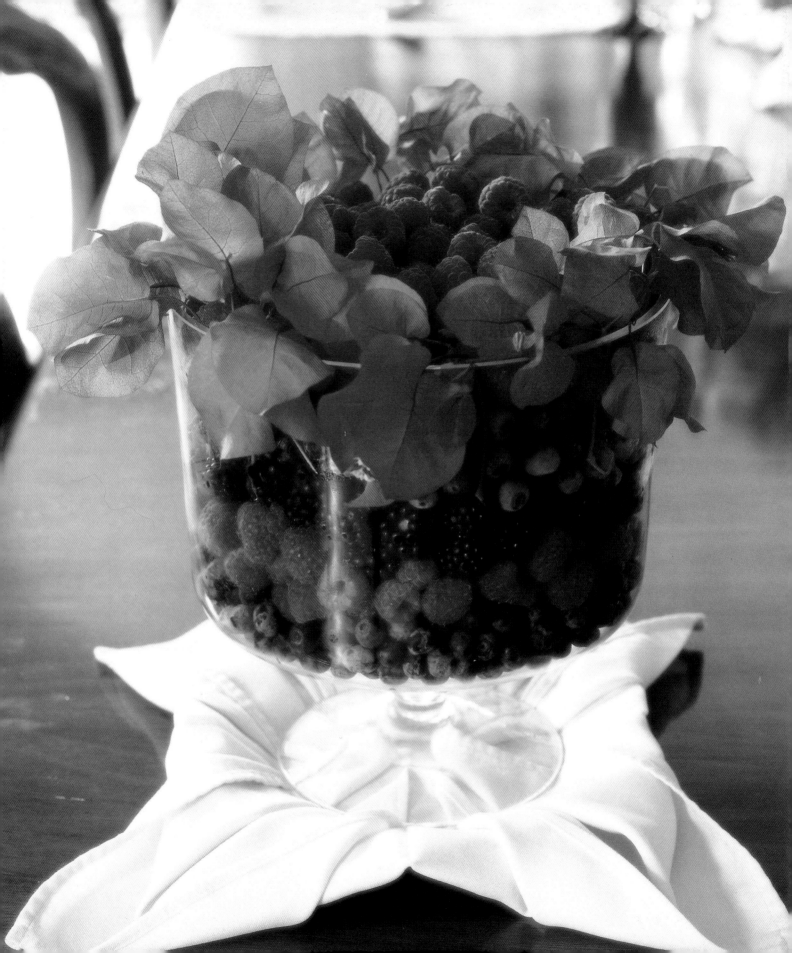

RED on RED

creating stunning
interiors using
reds and pinks

STEPHANIE
HOPPEN

A BULFINCH PRESS BOOK
Little, Brown and Company
BOSTON · NEW YORK · LONDON

acknowledgments

The help I had from friends, colleagues, and total strangers has been so overwhelming that I feel almost duty bound to write a whole chapter extolling the many kindnesses we experienced. I can, however, not even begin to extol these many kindnesses without saying how much I depend on Cindy Richards — my editor, my advisor, and my very good friend. At every stage we work — and argue — together and out of all this a great synergy emerges. In no particular order I want to thank the following people without whose amazing help and interest this book could never have been dreamed of. Bernie de Le Cuona, who redecorated a room to inspire us and who once again opened her house and her heart to us. Where would we be without her style and chic and charm.

Kate Bannister who welcomed us into her amazing apartment four hours late and never made us feel unwelcome.

Stuart Hands who, as always, worked unstintingly to give us everything we wanted and things we had not dreamed of.

Susan de Rose, Richard Lewis and Pamela and Neil Isdell.

Ray Harris who gave us his wonderful design studio and all of his divine pleated clothes for a long afternoon without demur.

Axel Vervoordt who opened his home and his wonderful showrooms to us one rainy winter day. The kindness, help and lovely lunch given to us by Anne Marie. The beauty of everything we saw will remain with us always.

Stephanie Stokes and Tito Pedrini.

In Cape Town Gillian Stoltzman helped us to put everything together and schedule a very tight week. Thereafter at every turn we experienced only kindness, helpfulness and generosity from Sidduk Kallay, everyone in Bokaap, Mogamed, Juliette and Stephen de Combes, Shane Petzer and Scott Hart, Mario Lucangiola and Ali Dewajee, Liz Fallon and everyone at *House and Garden* South Africa, especially Liz Morris.

Marianne Fassler who welcomed us in spite of her busyness.

Gill Segal who found us a Cameroons Pygmy hat.

And finally, thanks to Beezy Bailey.

Page 2: A bowl of layered mixed berries and bougainvillea flowers, styled by Elisabeth Brandt of Serenitee Cape Town, encapsulates the exquisite sunny day in January 2001 when we all brunched together at Serenitee to thank everyone for their unstinting help in finding all the Cape Town locations.

CONTENTS

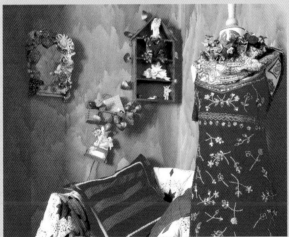

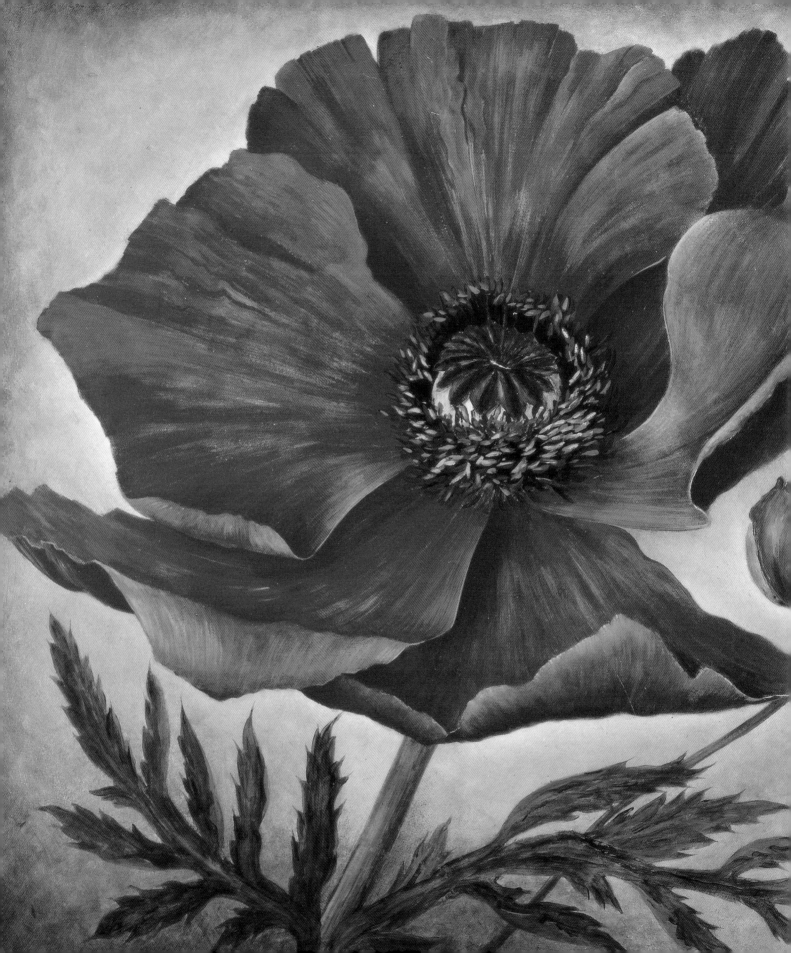

GALLEY.2001.

seeing
red

R ed is vibrant and energizing, glamorous and sexy, or warm and comforting. After a decade of minimalism, I believe that this most glorious and adaptable of all decorating colours — from deep baroque crimsons and scarlets to vibrant gypsy fuschia, through a spectrum of ochre, poppy, tomato, and the lovely country raspberry-and-cream pinks — is now back at the heart of fashion. You can use a single splash of red to add warmth and impact: choose from myriad lipstick shades of berry, orange, strawberry, or carmine in accessories, such as cushions or rugs, to create a baroque, contemporary, or bohemian atmosphere. And, if you want to make a dramatic statement, you can layer red on red for decorating on a grand scale.

This poppy painting by Galley defines what I call the "essence of red." It could be hung as a single dramatic statement in a neutral room or would mix in with red cushions, rugs, flowers, and other accessories.

introduction

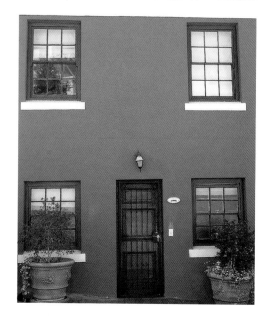

Red is a wonderful colour for the outside of houses as well as the inside. In shooting this book I travelled to the slopes above Cape Town, to Bokaap, a village built by Cape Malay craftsmen in the eighteenth century. Over the years, the houses became run down but recently the council traced the descendants of the original inhabitants and helped them to buy back and renovate their old family homes. They are now beautifully restored with an atmosphere of a real community and a small mosque on every street corner. Each house is painted in a different candy colour, and there is still a tradition of craftsmanship, with a thriving community of real artisans living and working in an enchanting ambience.

The reds and pinks here work best under the fierce tropical and sub-tropical sun, but you can still use red on houses in gentler Northern climates, where it adds a splash of warmth and colour. I love the raspberry pinks of city terraces in Chelsea, London, or Greenwich Village, New York, for example, or the creamy tomato reds of the southern regions of France.

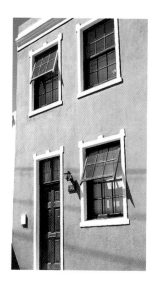

red
on red

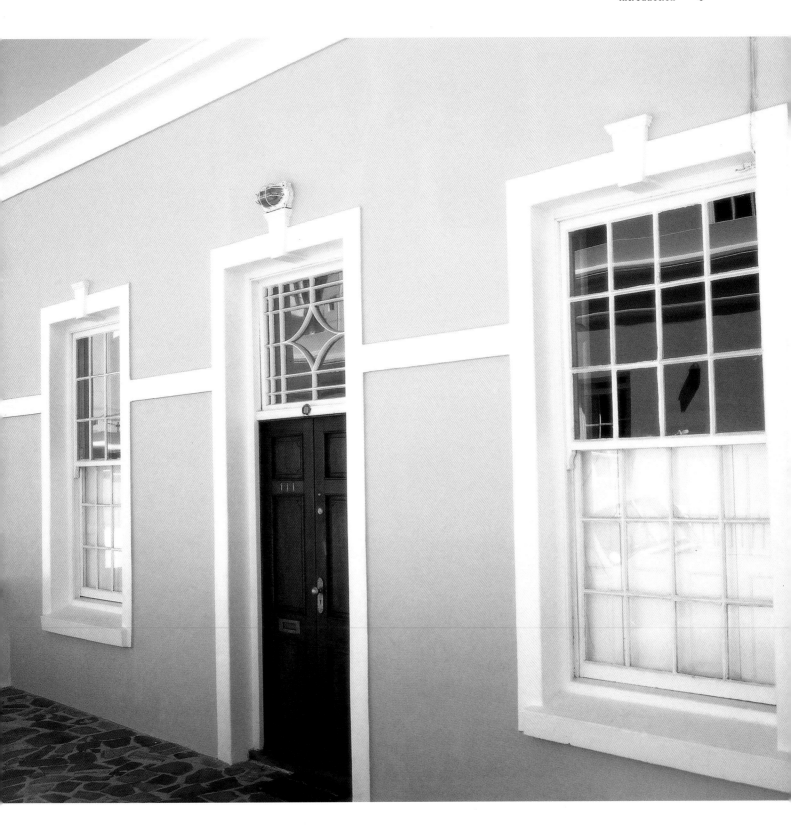

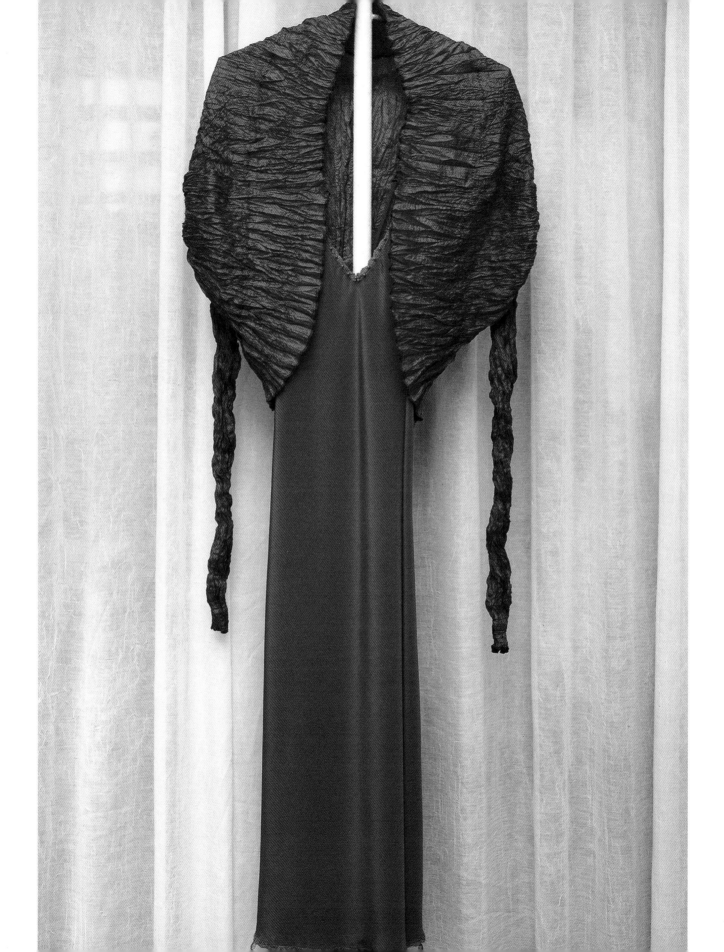

Fashion and the home now influence each other as never before — the wonderful clashing combinations of reds, pinks and oranges worn on London's most stylish streets are now echoed in cushions, bedlinen and flower arrangements. But if you're still wary of using this wonderful colour in your home, here are my top ten golden rules for using red:

◆ Start on a small scale: red flowers, red cushions, or a red table setting.

◆ Don't choose paint or fabric from small swatches. Red, above all other colours, appears different over a large area. Paint large panels and invest in large swatches.

◆ You can mix different tones or shades of red, but avoid both together. Reds with pinky undertones will look good together, as will reds with orangey ones. If you're mixing pinks and oranges, keep to the same strength or vibrancy.

◆ In paint colours there are "good" reds and bad ones (see page 156-157.)

◆ Red is a wonderful accent colour. Add a single element to a room, such as a modern painting.

◆ The classic "red room" needn't be restricted to an English country house, it can be warm and welcoming in a tiny, modern apartment.

◆ Using red is a striking way of decorating your house for a party. Red flowers, tablecloths, china or glass have instant impact.

◆ Red is a great background for paintings.

◆ Be restrained with red flooring. Add kilims, Bokhara, Persian, and modern rugs but avoid a red wall-to-wall carpet.

◆ Keep a personal "red" file of magazine pictures, postcards, and so on to inspire you.

left: This exquisite pleated silk dress by fashion designer *extraordinaire* Ray Harris, who creates stunning ensembles that flatter any shape and size and come in fabulous colors, is both something to wear and decoration for the home.

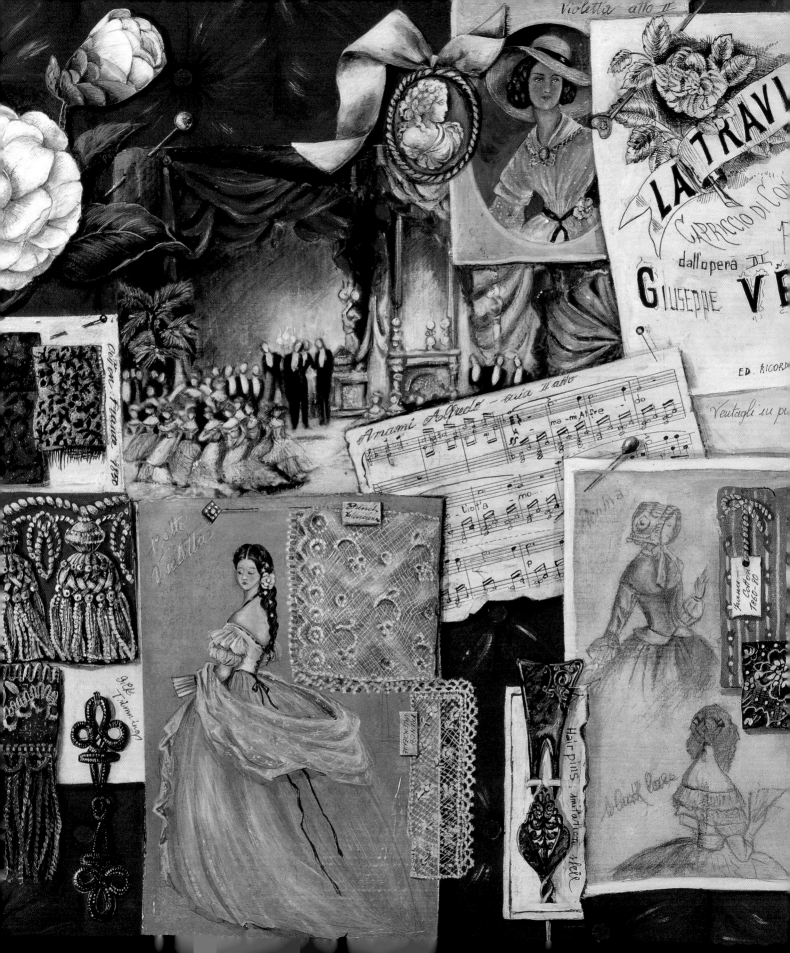

Baroque

The grand red room is one of the great decorating classics. Even at the height of minimalism, there will always be a demand for it. If I want to create a wonderful dramatic statement in an entrance hall, a dining room or even a drawing room, this approach is the most effective. Red has always been a colour of contradictions: the epitome of grandeur and passion, it is also warm, welcoming, and comforting. In its most vibrant forms, red can be outrageous and daring, yet its subtler tones are also the most feminine and easy-to-live-with colours in the spectrum. In the past, red was considered a classic decorating colour for grand houses but now, using it in a Baroque style, it is perfect for fashionable homes and smaller houses too.

This sample board based on the opera *La Traviata* sums up my inspiration for Baroque red rooms. In a Baroque room, antiques jostle with keepsakes, and everything is richly textured in velvet, chenille, or brocade. Flowers are in full bloom and even the accent colours — usually gold or silver — denote wealth and sumptuousness. It is a decorating style most usually associated with the formal rooms of grand English houses, but such Baroque red rooms can also be achieved in small rooms or on a tight budget. The antiques need not be perfect — in fact, the cracks, tarnishing, and broken bits that detract from their value add atmosphere to a room. Large swirling gestures with curtains can be executed in humble fabrics in rich red shades, while the more expensive fabrics can be used sparingly, as an occasional accent.

This sample board painted by Marinella Angelini is based on the opera *La Traviata* and was created by Marinella and theatre designer Maria Pia.

is
back

After years of minimalist neutrals and naturals there is now a real desire to return to the flamboyance of Baroque.

You can create the atmosphere with just one or two grand dramatic statements in a room: an ornate gilt mirror, a stunning curtain treatment or a lavish flower display. As Baroque becomes increasingly fashionable, you can find some of the elements in local stores – for example, when leather and animal prints stalk the catwalk, their use in floorings and furnishings is never far behind. Look for leopard-print or leather cushions, leather chairs and sofas, or even leather walls. Now that red is today's hottest fashion colour, you'll find an excellent choice of red accessories in the shops, too.

Even more dramatic, but slightly more difficult to pull off, is a stunning layered look: red walls, red curtains, and soft furnishings, elaborate gilt or silver mirrors to reflect and repeat the elements and a few key touches, such as cranberry glass, opulent flower arrangements, or rich leather books or symbols that hint at ancestral wealth, such as heraldic emblems.

Yet even for this look you don't need to live in a grand house. It also works beautifully in small, boxy rooms, basement dining rooms, rooms with little or no natural light, and in hallways. The richness of the approach distracts the eye from the actual size and architecture of the room and the mirrors can entice and deceive to make the space seem grander than it is.

If you do want to paint the whole room red, make sure you take time choosing the colour, because there are good and bad shades of red. My favourite choices all work well in a variety of rooms (see page 156-157).

Texture is the next key feature of Baroque. Use luxurious fabrics, such as velvet, chenille, brocade, and damask, or classic patterns such as paisleys. Be bold with accessories – unlike walls or major pieces of furniture, they are easy to change around.

The next element is to introduce the "accent" colour – something that highlights the richness of the red. Either silver or gold – in mirrors or picture frames, for example – adds the right touch of extravagance. In furniture, dark or richly coloured woods work best, not light pine or beech. The final touch for the evening is to add lots of candles, rich cranberry glass, and exuberant arrangements of red flowers or fruit.

Cranberry glass responds extraordinarily well to candlelight – the combination epitomizes the Baroque look.

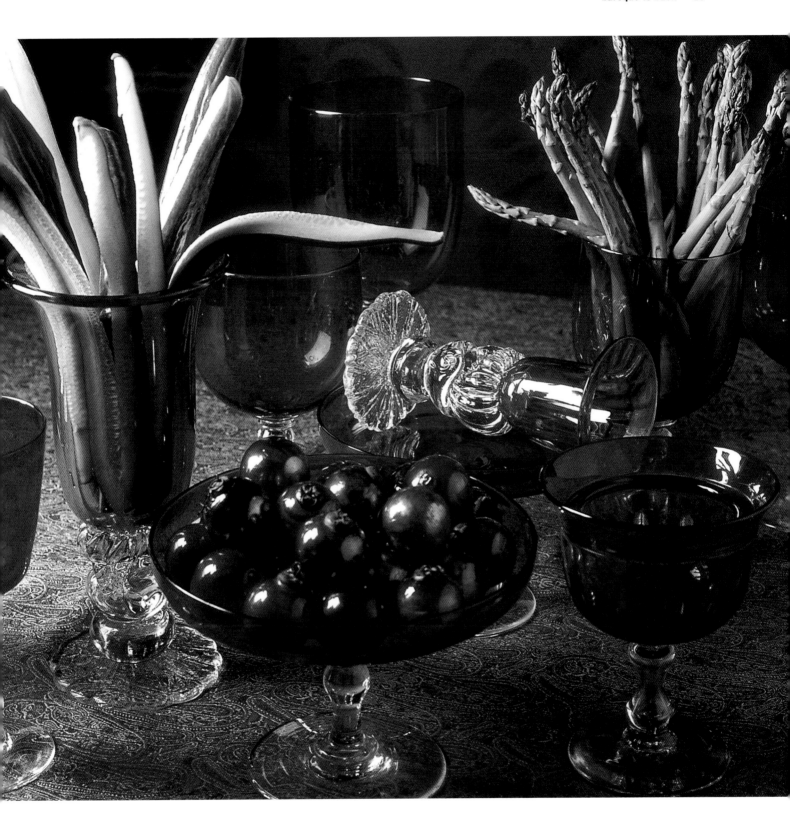

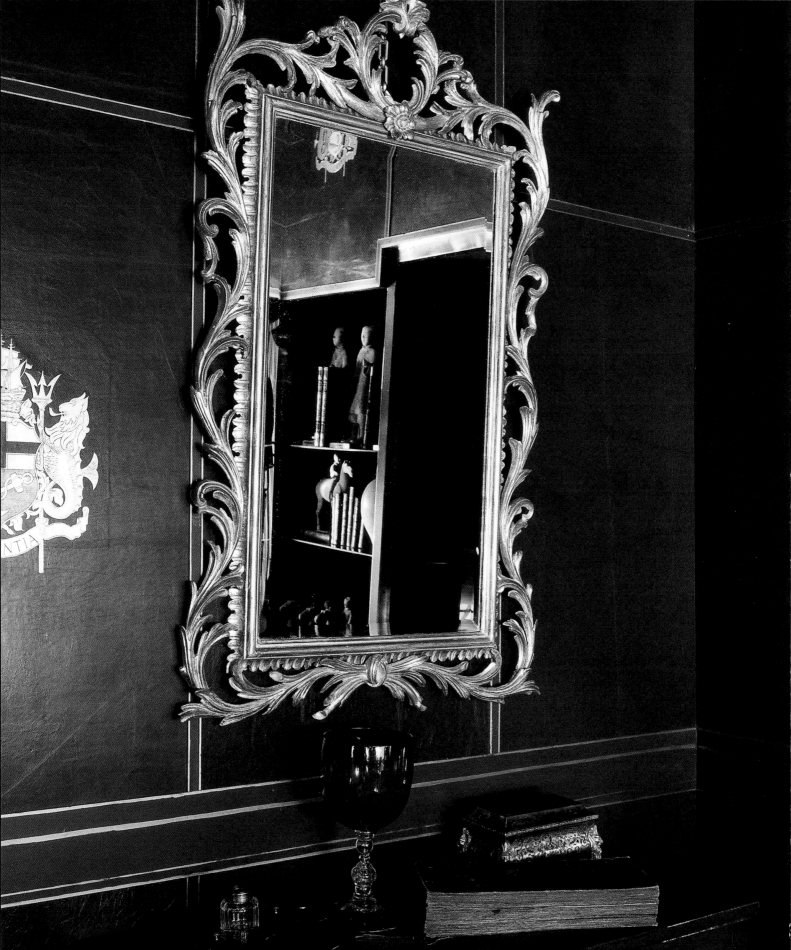

Baroque

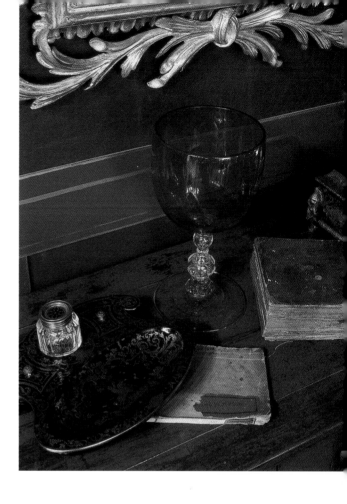

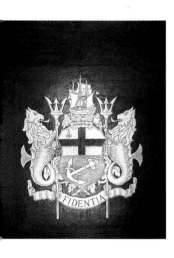

This glorious red room was paneled in red leather printed with heraldic motifs by the antique dealers Guinevere. Using leather for walls, cushions, and floors is a trend that has crossed over from the fashion for stylish leather clothes, and it shows how a traditional room can also be very contemporary.

Guinevere in London is a wonderful shop to visit to see antiques set out as if they were in the home, and it stocks everything from linens to larger pieces of furniture. If you're buying antiques generally, remember that they don't have to be in perfect condition to be decorative. A touch of fading grandeur can be just as effective, and sets will always attract a premium, so it is cheaper to buy, say, a beautiful glass, singly.

above: A marvelous heraldic crest looks very effective when repeated around the room.

top right: A Victorian boulle inkstand with a tortoiseshell inlay, leatherbound books, and cranberry glass create a Baroque "still life".

left: An 18th-century Continental carved giltwood mirror looks striking against the red leather.

interiors

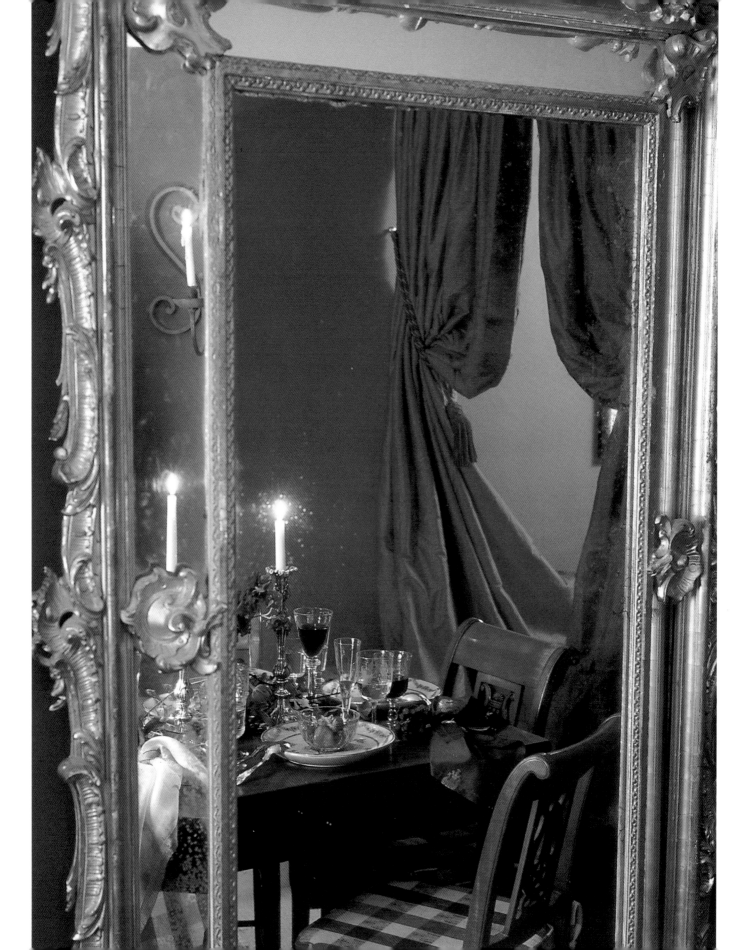

dining
in red

left: When decorating a room for a party, red is the colour that offers the most impact for the least cost and effort. It's also a great way to experiment: start with a red table setting and move on to a complete red dining room like this: a stunning mix of old and new with an antique Georgian dining table and chairs updated by fresh, modern country check seats.

right: A detail of the drapes shows how a two-colour silk stripe edging gives an added sense of movement. These two reds are similar in tone, which is why they work so well together, although one is actually deeper than the other.

Red is at the very heart of luxurious entertaining. I love to cosset my guests with all the hues of this wonderful colour in my dining room; from velvet-embroidered table drapes in deep mulberry to claret-red goblets that just beg to be replenished, red creates a warm, vibrant atmosphere like no other. This beautiful red dining room designed by curtain-maker extraordinaire, Stuart Hands, is the ultimate in evening glamour, yet it also offers warmth, intimacy, and comfort, making it perfect both for grand dinner parties and great occasions as well as for cozy celebrations with friends and family.

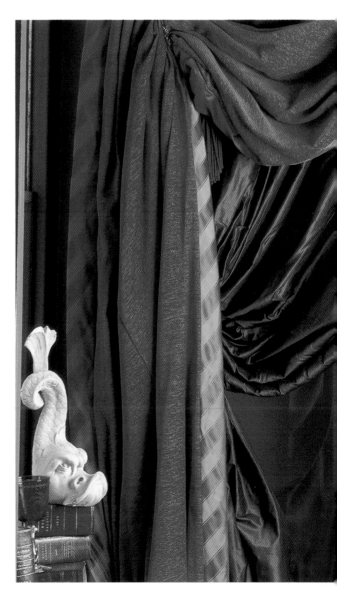

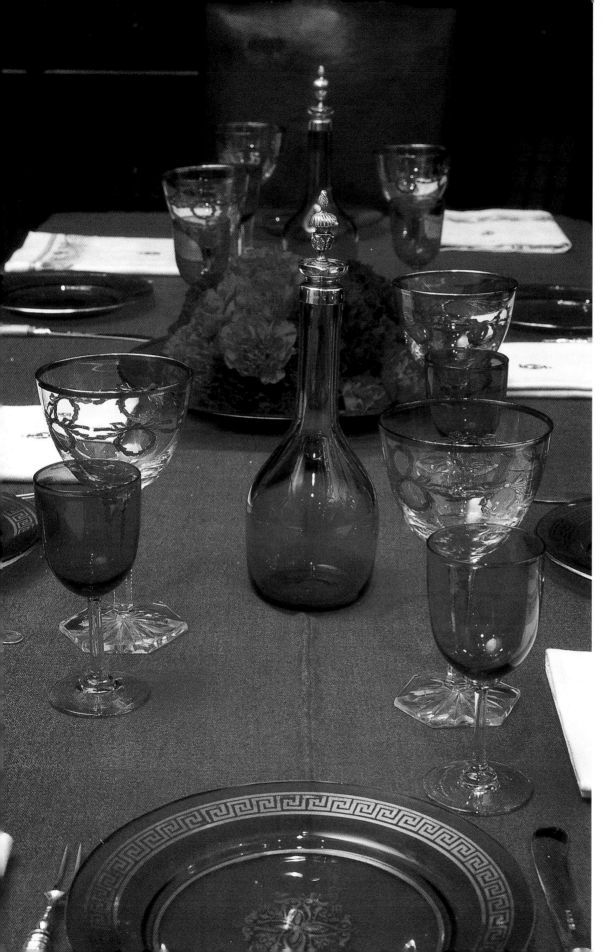

left: This simple, yet striking, laid table at Guinevere combines a tablecloth dyed with vegetable dye for a soft, antiqued effect, red glass, and napkins embroidered in red.

right: Stuart Hands' opulent dining room demonstrates the effectiveness of a Baroque red theme with candlelight. Crowd a table like this up; mix elaborate candlesticks with silk-edged napkins and patterned china.

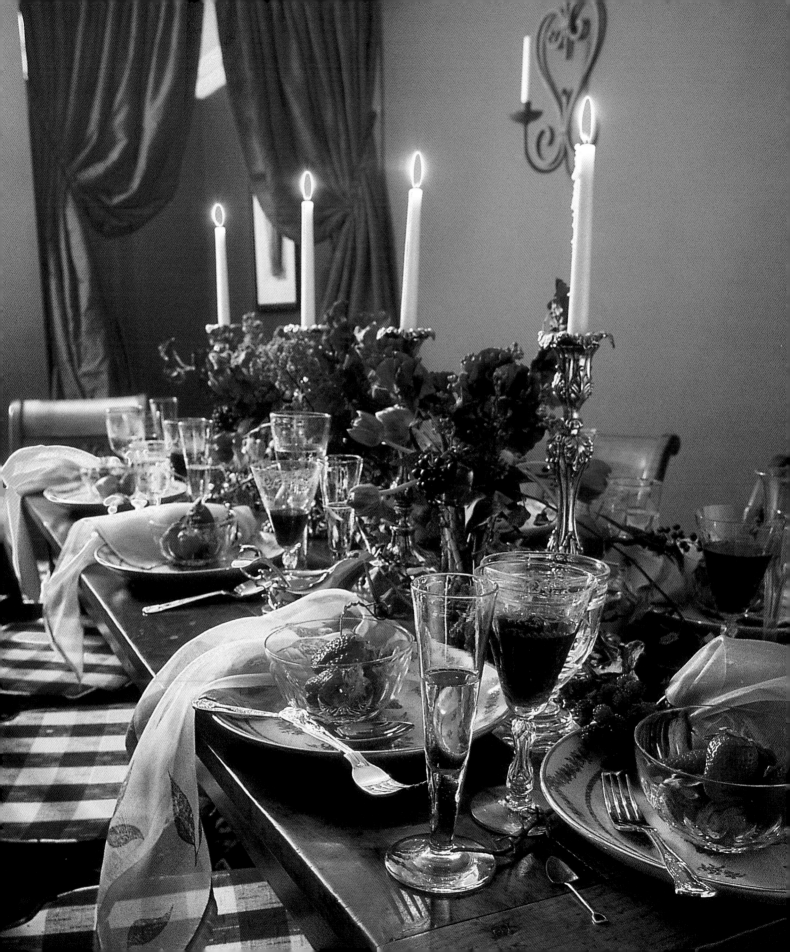

inspired
by echoes

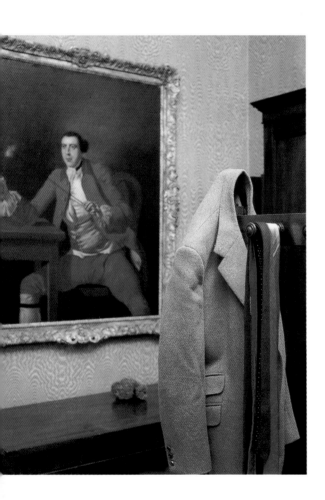

I love this dressing room in the castle of 's-Gravenwezel in Antwerp, the home of Axel Vervoordt. He is a designer and dealer, who has the most unusual and exquisite taste and style, and always manages to juxtapose interesting mixtures together. Here, he has used a wonderful painting of a man dressed in red as the starting point for the decor of the dressing room. The walls are red and the furniture in the room mirrors the furniture shown in the portrait. If you have a favourite picture, you could use it as inspiration for a room in a similar way.

right and left: The red suit and the simple wood table in the portrait form the starting point for this dressing room's decorative scheme.

following pages: A view of Axel Vervoordt's music room in a mirror. I arranged the *sang-de-boeuf* Chinese vases on the mantelpiece, and such is Axel's sense of where to place things that he identified the final touch: aubergine candles in French Empire gilded bronze candelabra. This simple detail transformed the mantelscape.

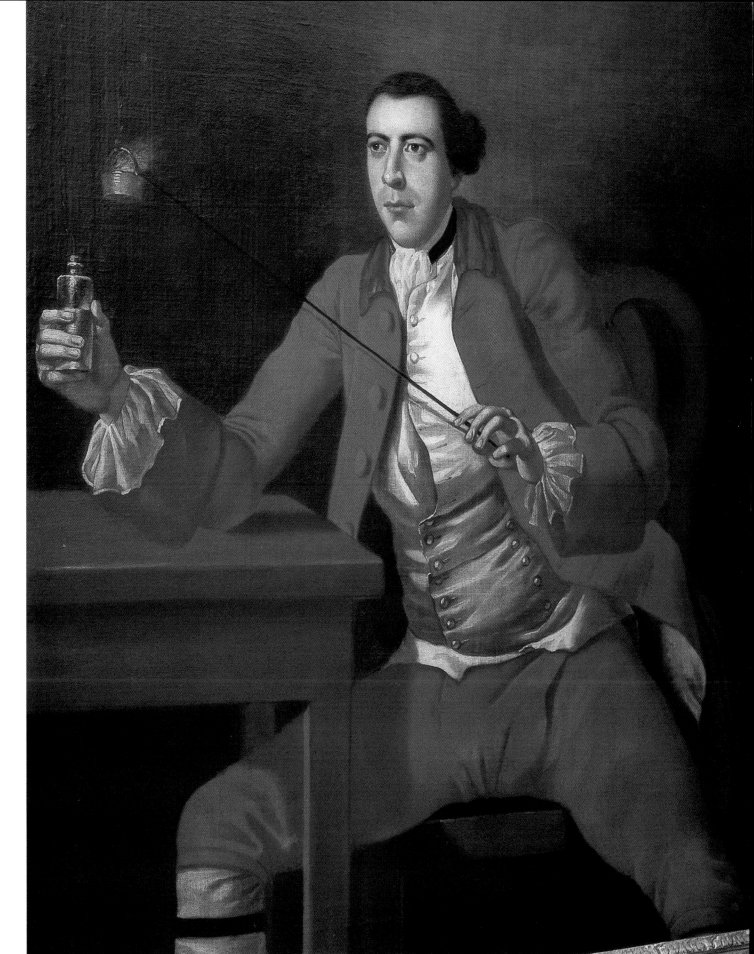

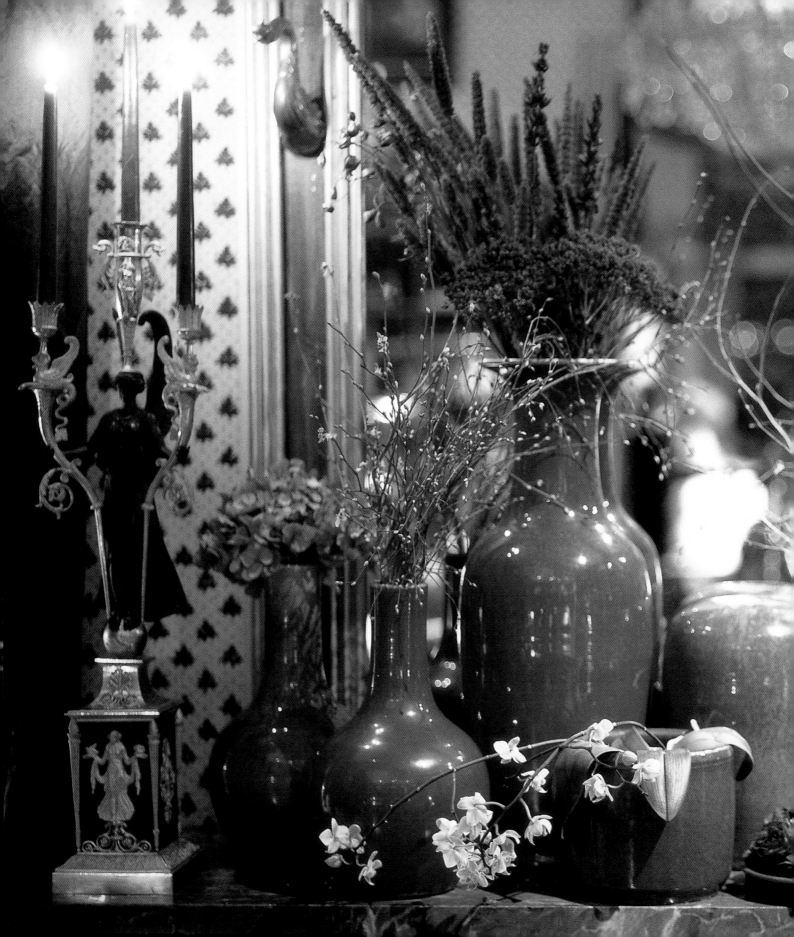

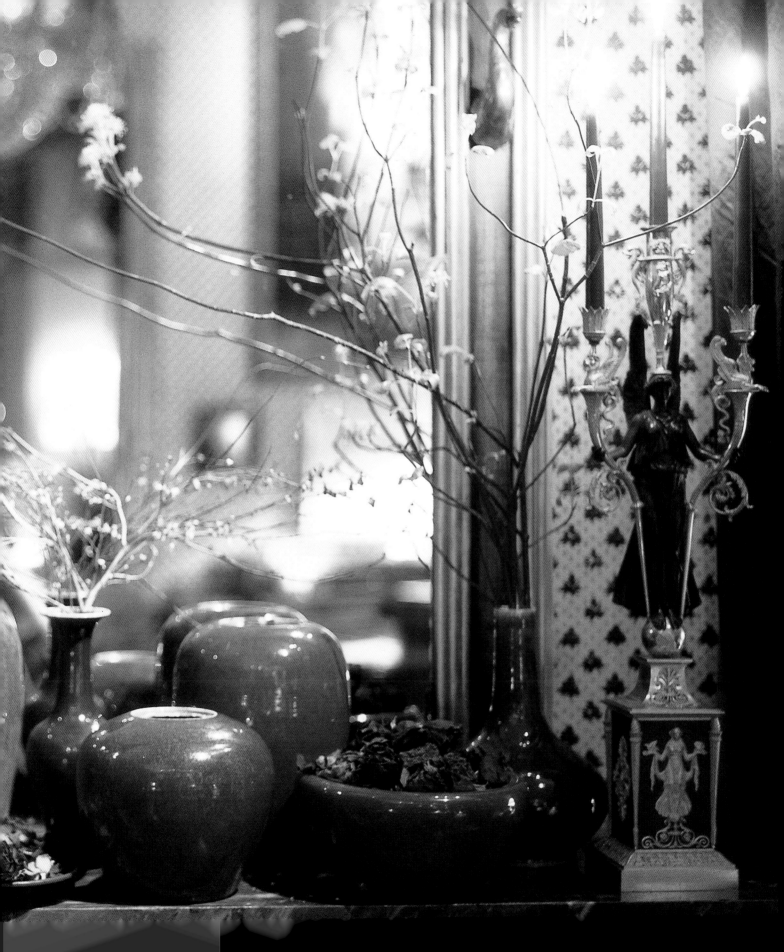

left: Try out unusual
combinations when
working with flowers and
plants, such as this novel
twig and feather
Christmas tree.

left: Florist Annie Khan
always considers texture
as well as colour when
planning flowers: contrast
shiny berries with softer,
more velvety textures.

below: Remember to think
about how the flowers
work with your napkins,
china, and glass. Here
gold napkins are the
perfect partner to red.

celebrations

Red is the perfect colour for creating a festive

atmosphere because a little has a tremendous

impact on a room. Experimenting with

flowers is one of the best ways of developing

an eye in the use of colour, and reds look

wonderful all year round. These arrangements

were created by Annie Khan, one of the most

talented florists I know in London — her

Christmas tree with twigs and feathers, shown

here in my dining room, is a brilliant

interpretation of a traditional tree.

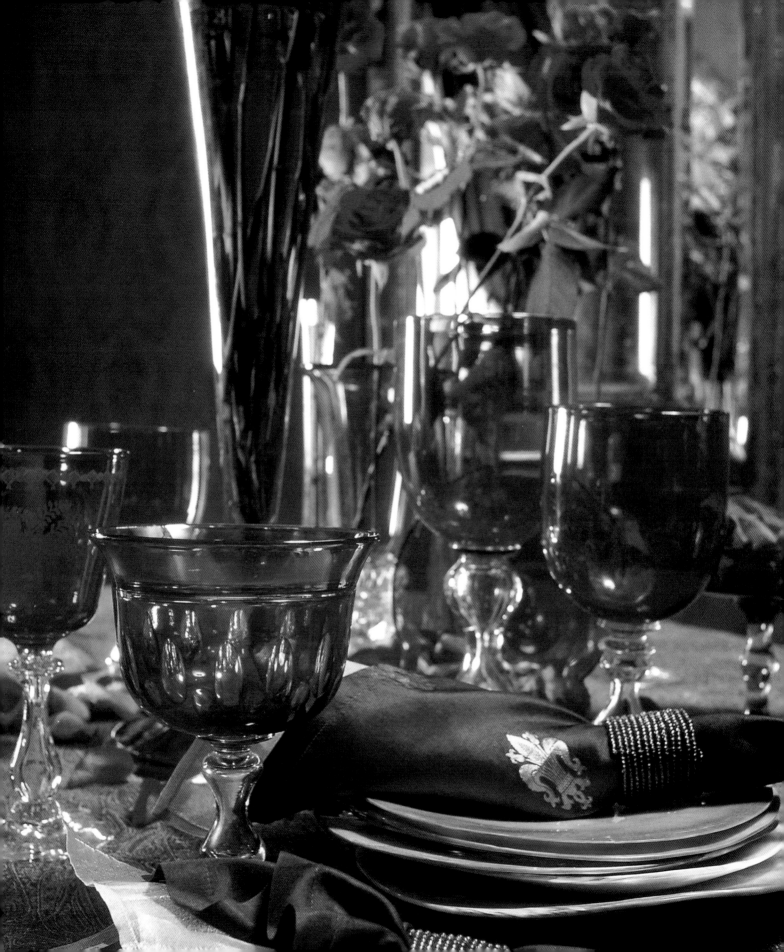

left: Annie Khan suggests you match the shape of the table to the flowers as with this round table and conical vase. Usually it's important to make sure that the flowers aren't too tall, so that people can talk over the top, but here the slenderness and transparency of the glass make talking easy.

right: The richness of the Baroque look involves crowding the table up: add layers of plates, coloured glass, napkins with ties, and wonderful flowers as I have done in my dining room.

red velvet

If there's one fabric that epitomizes the dramatic yet sensual qualities of red, it's velvet. Yet as a furnishing fabric it has been slightly out of fashion for some time. Now its sensual texture makes it a perfect choice for today. Use it in bedspreads, as tablecloths, in luxurious piles of cushions, and even tied around flower vases.

right: Talented florist Annie Khan mixes roses and red velvet – I think it's the most romantic combination imaginable.

below: This shows that silver is just as effective a partner to red as the more traditional linking of red and gold.

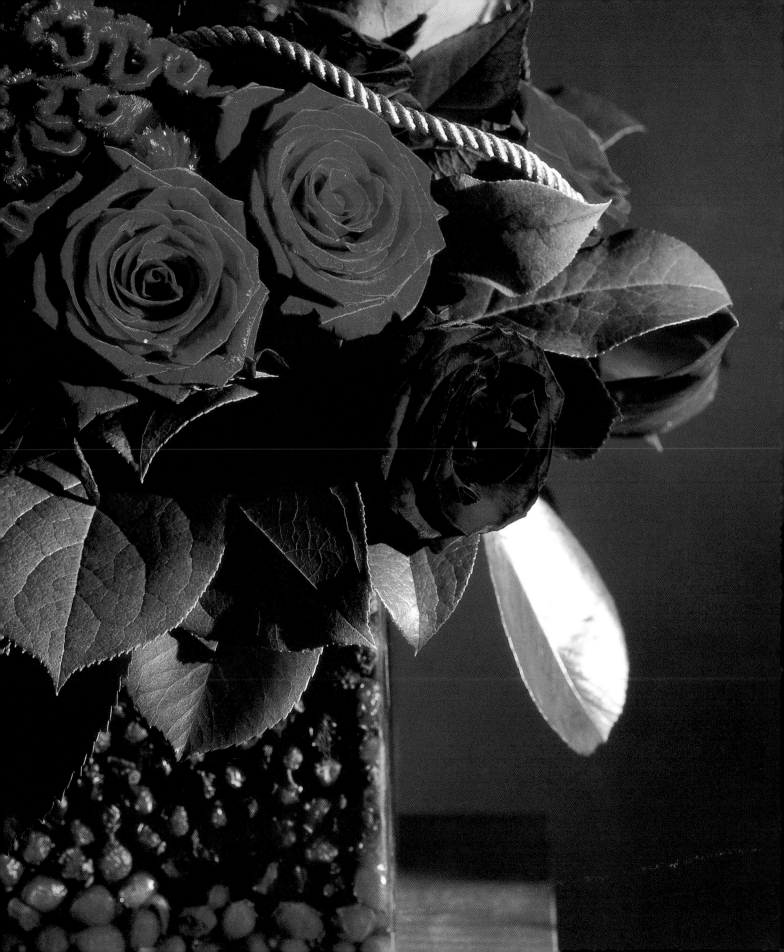

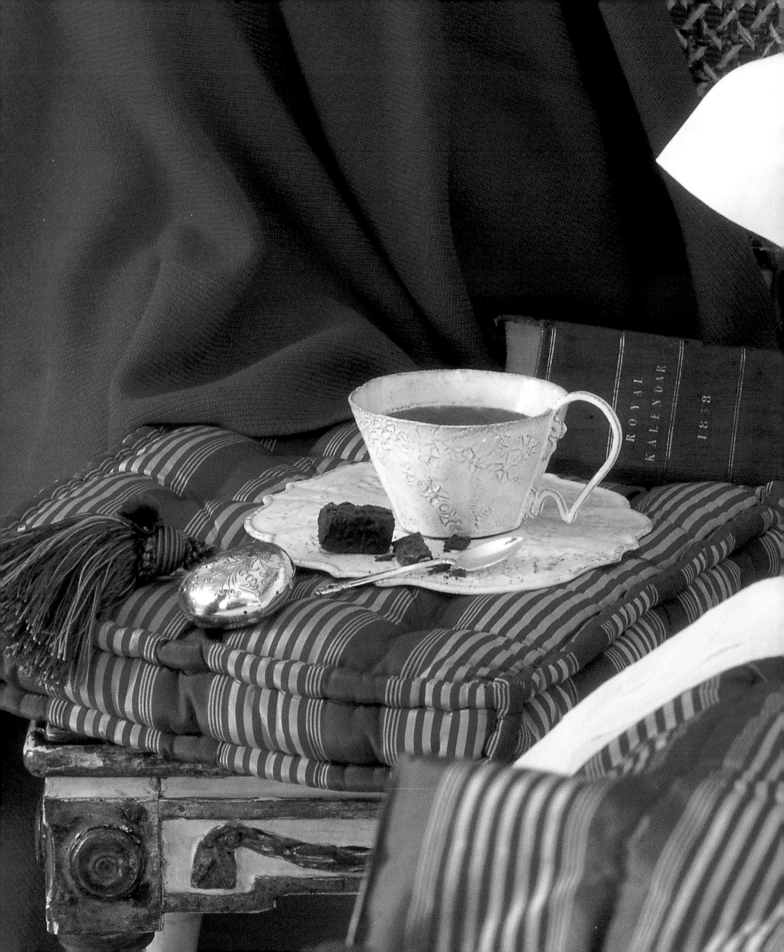

I've always thought red was too powerful for bedrooms, but this exquisite dark red velvet bedcover and matching red-edged pillowcases from Anne Singer's Monogrammed Linen Shop in London illustrates how simple it is to transform a white summer bedroom into a cozy winter haven.

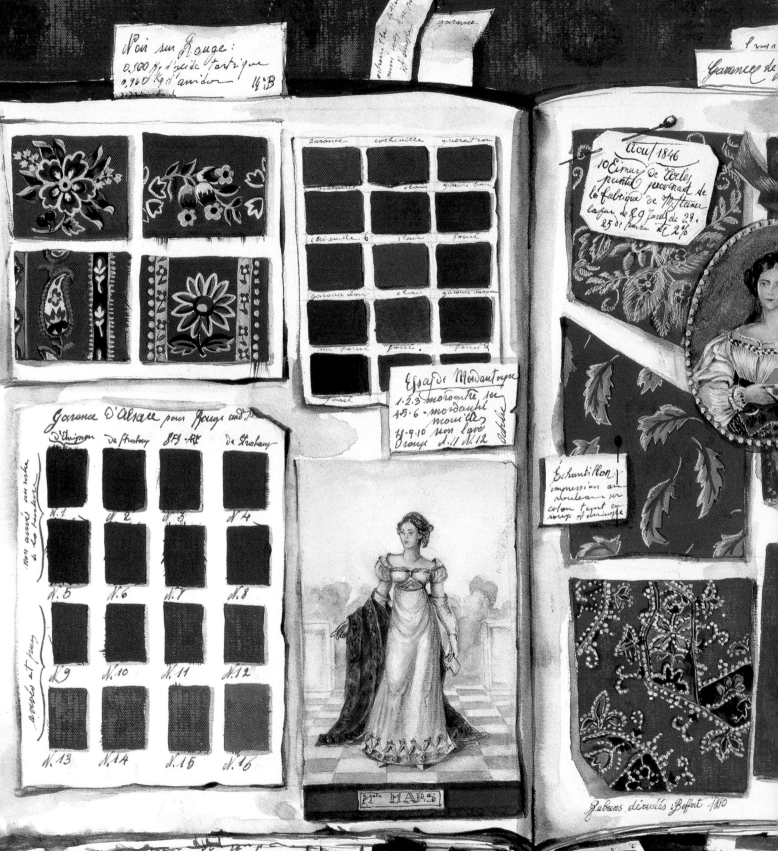

Classic

This sample board looks Classic, not so much because of the Greek – or Roman – inspired designs, but because it is welcoming and comfortable, yet very smart. It's like having a little black dress or a cashmere shawl in your wardrobe – you know you can rely on it to look elegant, and never to go out of fashion.

This is a look where colour can be used on a grand scale. While some Classical rooms are yellow, blue, or eau-de-Nil, red is often used dramatically, adding warmth to the formality, and conveying opulence and romance. There is nothing quite as splendid as a Classic red room as a setting for a stylish party, yet relaxing in the capacious, welcoming sofas of a grand drawing room is the perfect way to spend a lazy afternoon. It's a style that reflects the owner's interests, history and personality, with lots of pictures or photographs, occasional tables for lights, wonderful bookcases, and a profusion of ornaments all adding up to a unique decorating look that is both luxurious and comfortable. It's a remarkably forgiving

This painting of a sample board by Maria Pia and Marinella Angelini sums up Classic elegance and style.

chic

and relaxed way of organizing a room —
because the underlying arrangements are so
disciplined and balanced, any amount of
cushions and ornaments can be added on top
without the effect looking chaotic.

Red rooms have become associated with
the grandest houses from the eighteenth
century onward, to the extent that many
people may feel that you can only have this
look if you live in a Palladian mansion. While
it's true that rooms with red walls take time
and trouble to get right, it is a wonderful way
of combining a grand effect with comfort in
virtually any size of house. A study, library, or
tiny sitting room can look very effective done
up in the Classical style, but think carefully
about getting the basics, such as the shade of
red paint, exactly right.

This can look like a style that has no rules,
but a judicious amount of symmetry keeps it
from looking too cluttered. Pairs of things —
for example lamps or vases — look good placed

symmetrically opposite each other, such as two lamps on either side of the mantelpiece, two mirrors on the wall, and so on. You don't have to over-match everything: they may be two similar sofas facing each other, or they may be in different patterns — in fact, it's better if they are — but the overall effect should be one of balance. This creates a structure to which you can add almost anything: you can have a relatively empty room, or one stacked with chests, bookcases, and small tables. You can switch the elements around to make summer and winter rooms: red cushions, carpets, throws, and rugs in the winter, for example, and a lighter effect for the warmer months.

Detail is particularly important for this look: think about the tassels and trims, arrange a small *mise-en-scène* on every table, set out small collections in the most unexpected places, such as this collection of tiny mirrors, right, that antique dealer Kate Bannister has hung in the narrow, often neglected gap between two windows.

You can still achieve the look without going all the way — you don't have to paint the whole room red. If you love the Classic style of English decorating, red accessories are your best starting point. Blue and eau-de-Nil green, along with cream, are also typical of the look, but red — ranging from scarlet to rust tones — is at the heart of it. A sofa stacked with red cushions, kilims or Persian carpets, some *sang-de-boeuf* vases and opulent bowls of roses make a lovely beginning.

far left: Tassels make an intriguing alternative to handles on this fabric-covered cupboard. This would also work on plain wood.

left above: Red chessmen add a small, but effective, splash of colour and drama to a room.

far right: Convex mirrors were very popular from the mid-18th century. These miniature convex mirrors, dating from the 19th and 20th centuries, are made of either gilded wood or bronze. As a group they form a wonderful collection.

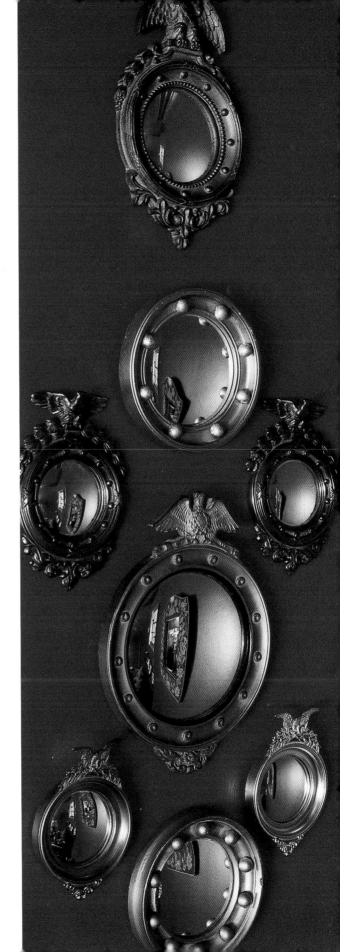

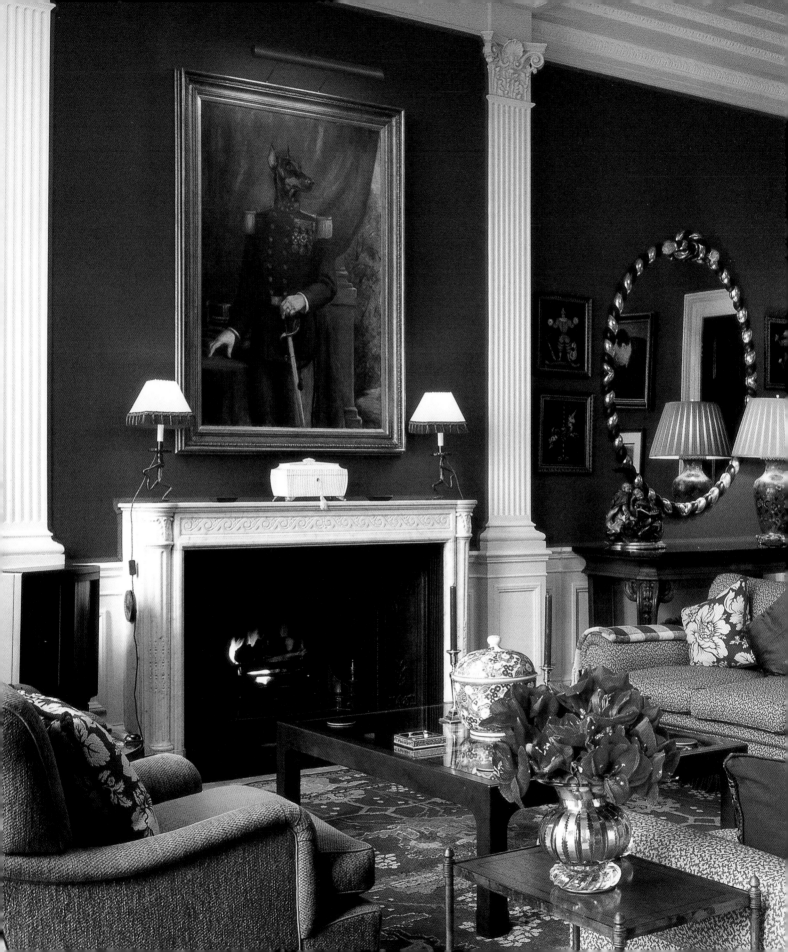

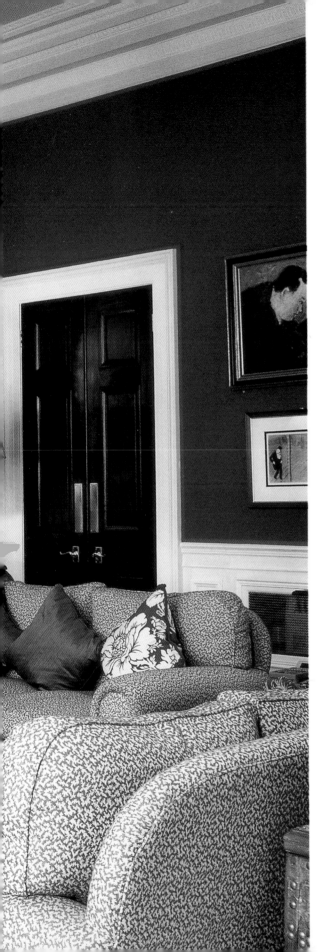

Classic interiors

I think that this room conveys the

quintessential elements of Classic decorating,

and is a lovely, easy, welcoming room to live

in. It starts with rich red walls and the

balanced geometry of Classical style, and on

top of this disciplined framework a profusion

of cushions, pictures, and artifacts add

warmth, opulence, and comfort.

Mirrors suit the Classic style particularly

well — hang them either above a mantelpiece

or on the wall with pictures around them. The

lighting is discreet, and is based on a number

of small lamps around the room — anything

modern, such as halogen downlighters, might

look a little too harsh for this atmosphere.

I think that this style of decorating will never look out of date, and will always be one of the few ways of furnishing a room so that it is both smart and comfortable.

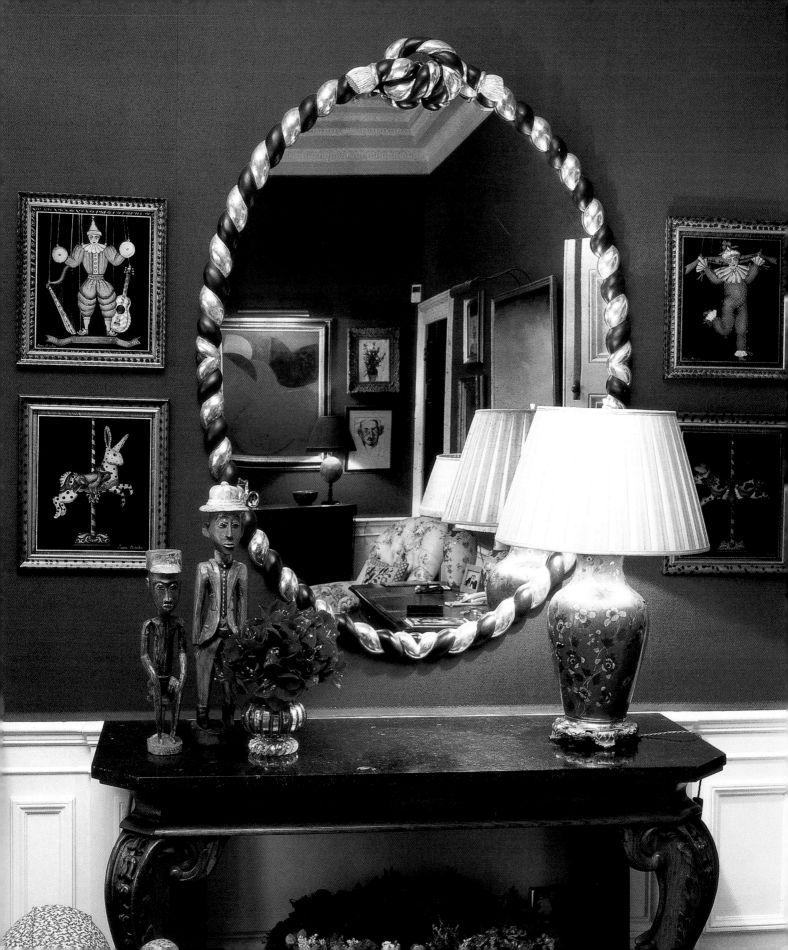

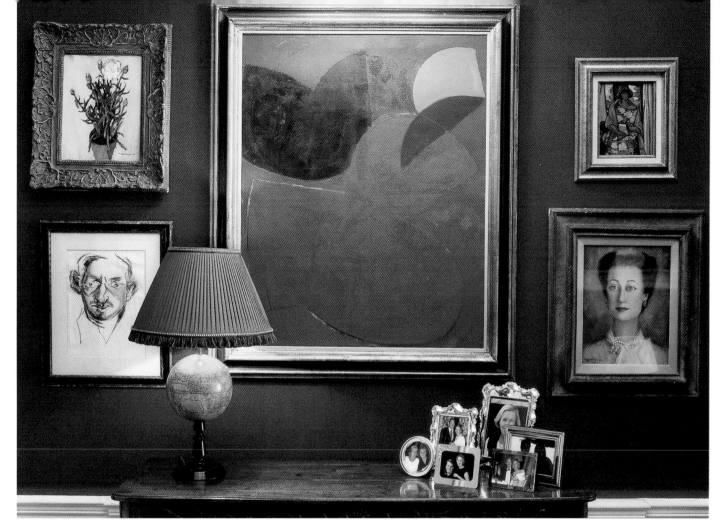

above: This *mise-en-scène* shows how modern and traditional paintings can look wonderful together in a red room.

left: The jewel-like quality of painted glass works beautifully against red walls. Hanging paintings geometrically in pairs is a typically Classical arrangement.

right: Adding an arrangement of rich red flowers to a red room always looks stunning. This bowl of cut amaryllis is simple and easy to copy, yet it conveys opulence. Introducing contrast, with a huge bowl of white flowers, for example, would also be very effective.

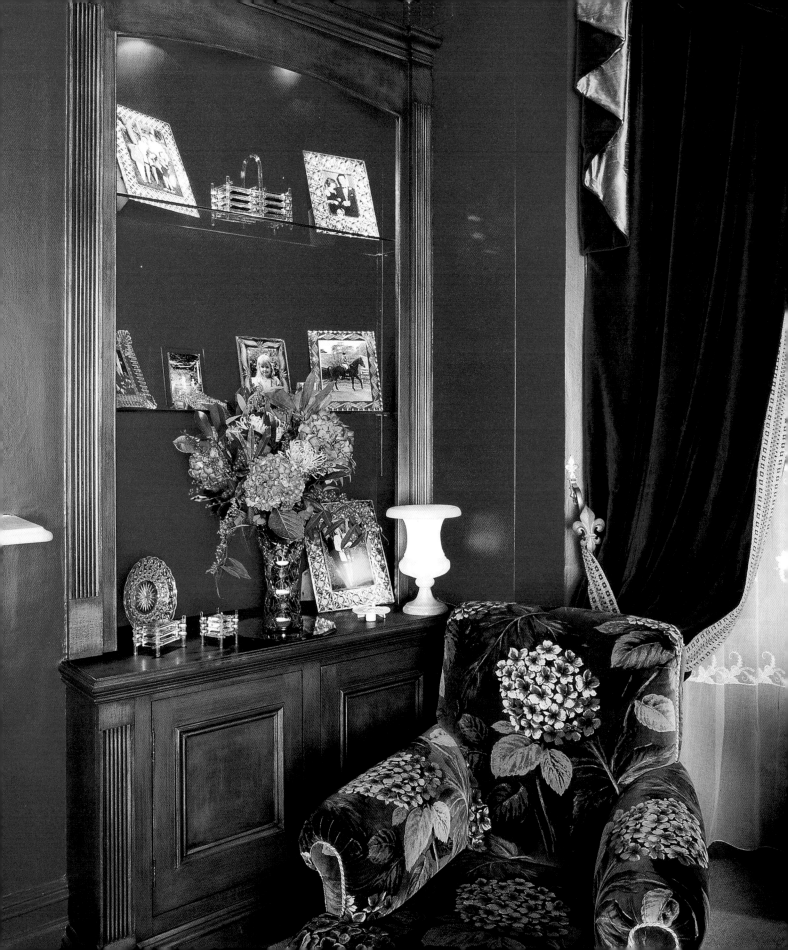

livable
red

The two rooms on these pages show how quite eccentric touches can be remarkably easy to live with. On the left, talented antique dealer Kate Bannister has covered an English armchair (circa 1880) in an original hydrangea print fabric. Look at the way she contrasts the textures of the red wall and the red velvet curtains which are made from late nineteenth-century theatre curtains.

On the right, a tiny hallway covered in striped red moiré almost looks painted, yet has a depth and texture that could only be achieved by fabric. Both these rooms show how you can use dramatic, strong patterns and colours together by keeping it simple.

far left: Antique dealer Kate Bannister's inspired choice of a 30s pink hydrangea print for her red room is echoed in a bowl of fresh pink hydrangeas, a clever trick to maximize impact.

below: Covering walls with fabric is one of my favourite designer tricks, as is the draping of a carpet over the table to create a stunning cloth. Here a striped red moiré paper was used on the walls.

New York
red

This stylish apartment belongs to Tito Pedrini,

a top international gemologist who grew up in

a traditionally furnished eighteenth-century

house in Italy. Even though this is the first

time he has decorated his own home, the

result is confident, contemporary, and

polished. Although he didn't have a master

plan, he knew which colours he wanted to

work with. He has used red either as an accent

or a background colour in many of his soft

furnishings and he's mixed modern furniture,

such as Carlyle sofas, Baker armchairs, and a

Gae Aulenti wheeltable, with eclectic items

and antiques. The effect is cultured yet

comfortable, sophisticated yet welcoming.

far left: Striped red fabrics from Ralph Lauren are perfect with Tito's individual look.

right The red accents on the soft furnishings unify the different red patterns on the armchair and the cushions, and emphasize the overall theme of the apartment.

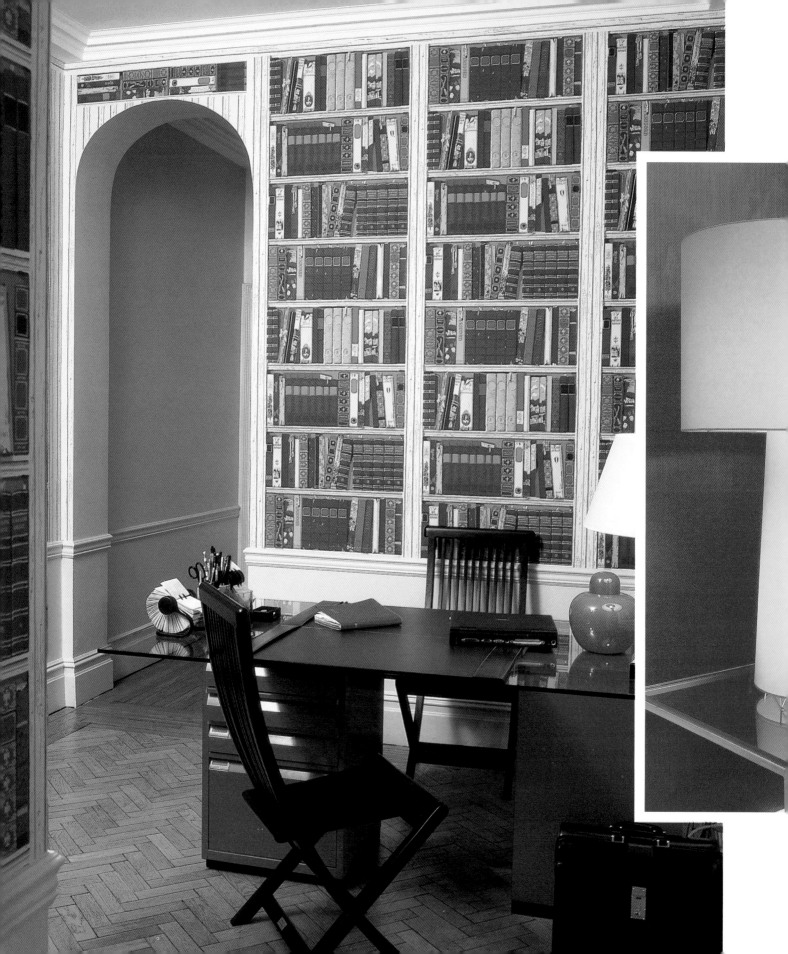

far left: The red Bibliotheque wallpaper from Brunschwig and Fils was installed by the previous owners.

left: Tito chose individual items like this stylish lamp and bowl piece by piece, with no preconceived notions about what the finished effect would be.

above right: A deer moss and curly willow stem composition from Manhattan's Lexington Gardens adds more drama than a conventional pot plant.

below right: Interior designer Stephanie Stokes' apartment shows the Classic look at its most pared-down: a single large picture dominating a wall and two matching wall lamps on either side.

red
effect

below: A contemporary geometric sculpture in bronze by Sjoerd Buysman entitled *Sylphium*, a unique piece created with the "lost wax" method.

far right: A view through one of the brewery's original windows becomes a work of art, with its contrasting white walls framing a simple late 17th-century pine folding Savonarola chair.

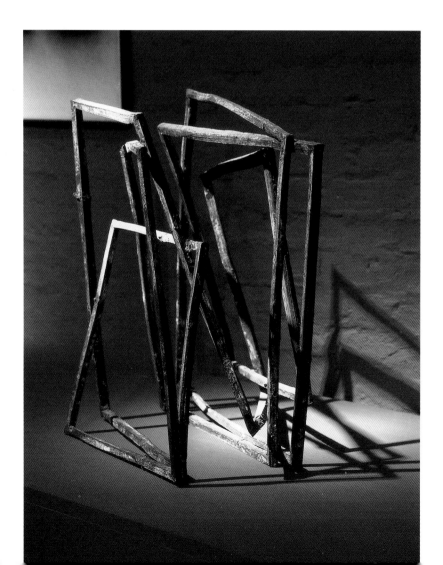

Axel Vervoordt, who designed these rooms, is a man with a purity of vision and a sense of style that is unique. I have never seen anyone with such an ability to juxtapose antique, modern, and ethnic elements together to create a harmonious interior. He took me to see this brewery, which he has transformed into a showroom, and to his home, the seventeenth-century castle of 's-Gravenwezel. In the brewery, he's taken the walls back to the brickwork and painted them red, creating a stunning backdrop for his furniture and works of art. It shows how good modern paintings look against a red backdrop – it's so much warmer than the plain white walls usually found in contemporary galleries.

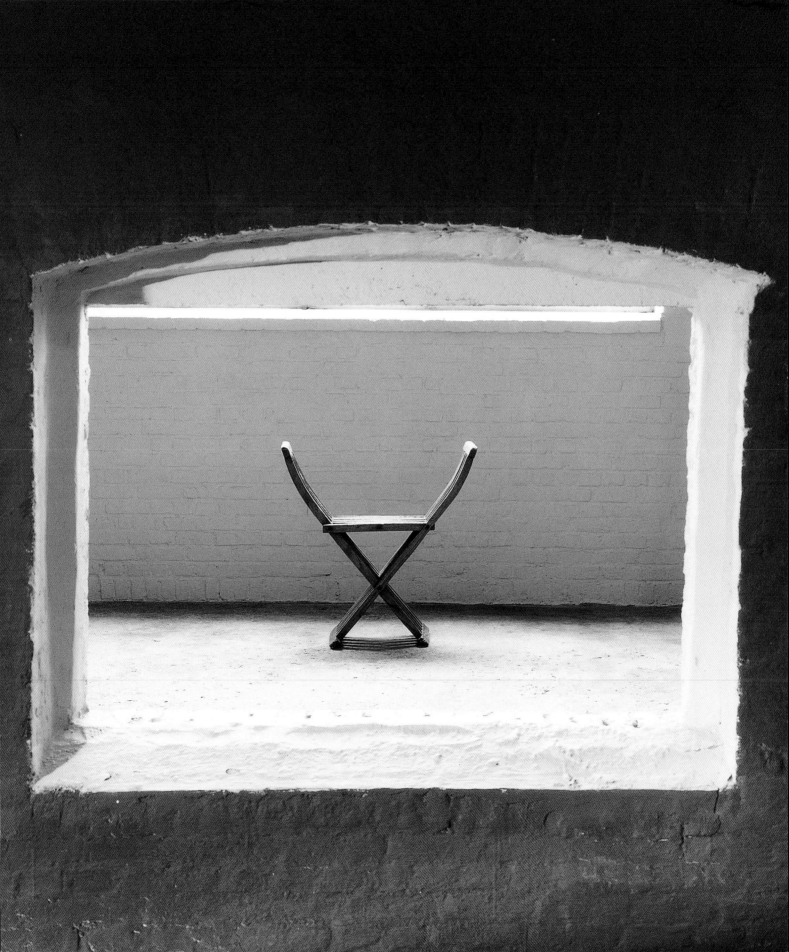

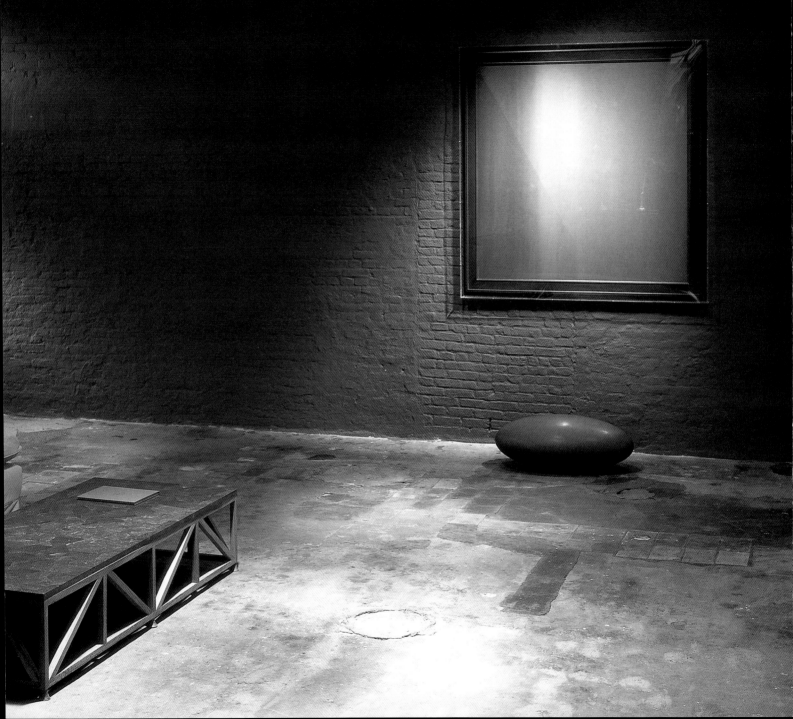

following pages: These three rectangular *sang-de-boeuf* censers in Chinese porcelain date from the Tao-kuang period of the 19th century.

left: A large blue abstract painting by Jef Verheyen called *Night Blue* is hung above an ellipsoidal form by Dominique Stroobant called *Pieta Serena*. The modern sofa-table is designed by Axel Vervoordt and has a lapis lazuli top and Egyptian base.

above and right: The effect of red or pink paintings on a red wall is quite astonishingly effective: these large abstract paintings by Jef Verheyen are acrylic on canvas.

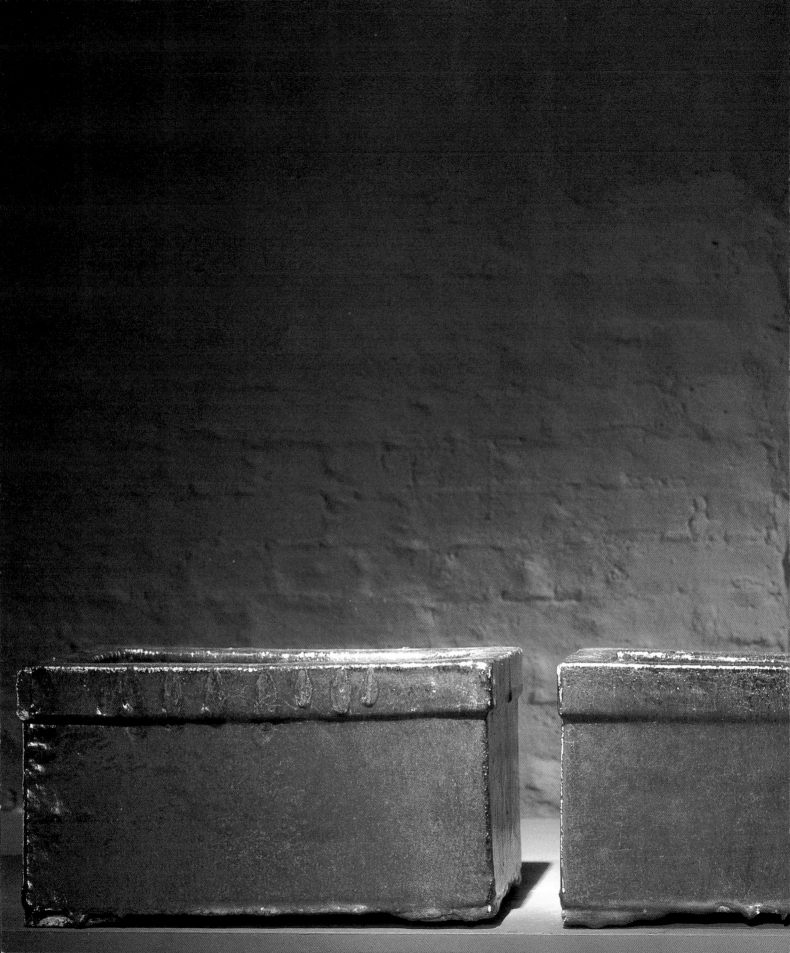

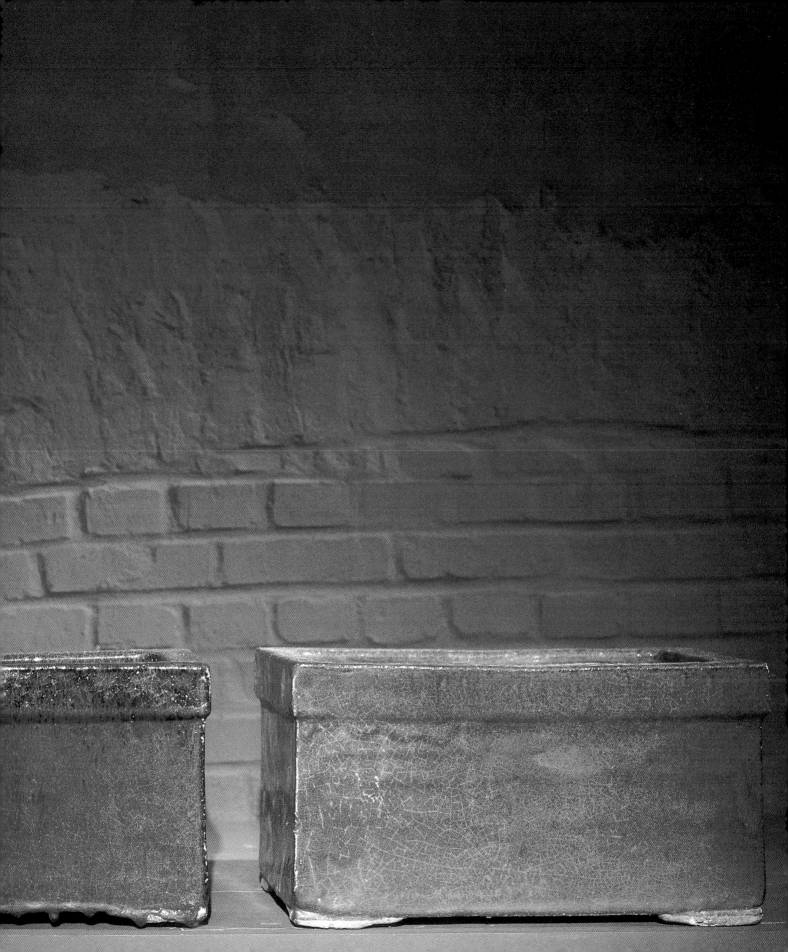

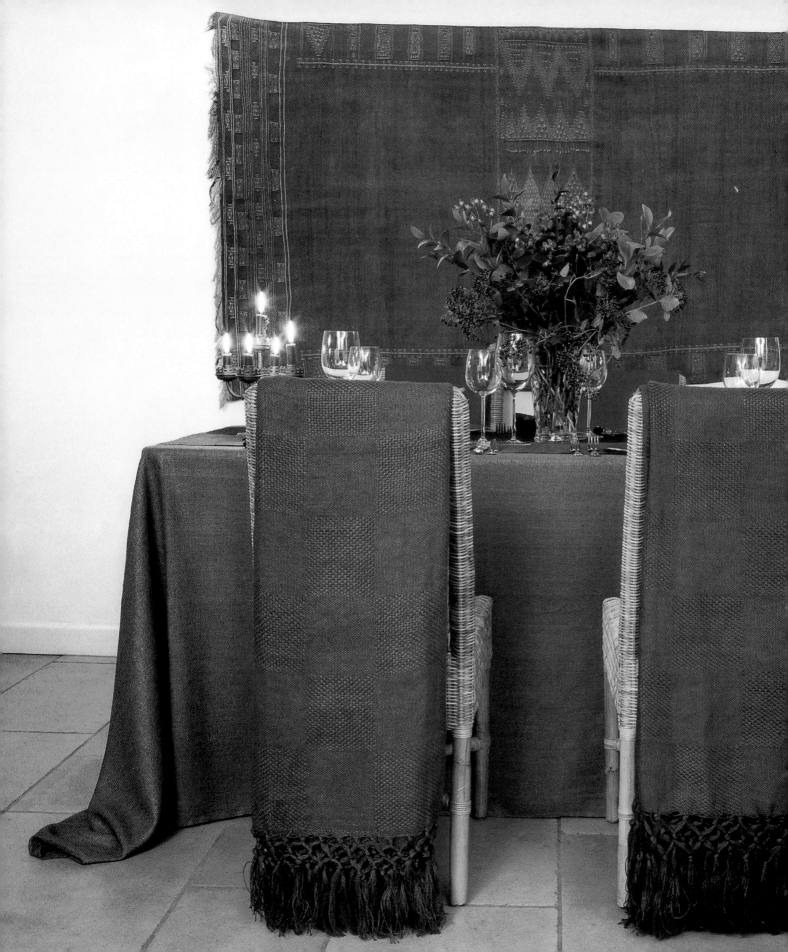

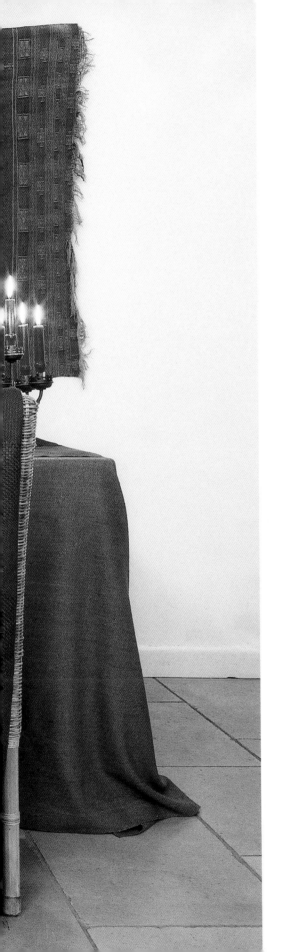

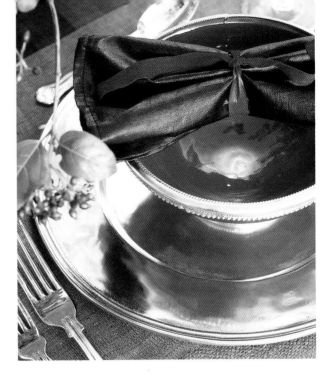

right: The contrast of a pewter plate with a glazed bowl is richly textured, yet subtle. The napkin is of glazed linen.

left: Bernie de Le Cuona's use of fabric is simple, yet creates an air of enchantment. An antique African hanging is the backdrop to a table set with a raw silk tablecloth. Linen throws transform plain chairs into striking thrones.

dining
in style

Bernie de Le Cuona believes you should create a

theatrical effect for entertaining. Here, within a Classic

table setting, is a wonderful use of layering reds on red.

You don't need to be constrained by the table linen

available in shops. Buy inexpensive remnants of fabulous

fabrics in sales baskets or markets and simply drape them

on the table. Often you don't even need to hem them.

sleeping

in style

One of the most effective ways of creating a

pampering, luxurious bedroom is to think

about texture as well as pattern when dressing

the bed. Here Bernie de Le Cuona has used

charcoal suede as the main bedspread — a

fashionable take on a classic item — and

layered it with a soft, cosseting alpaca blanket

and a pile of cushions in suede, raw silk, and

textural linen. The contrast of the softness of

the suede and the matt texture of the linen

gives the look depth. Attention to detail makes

the cushions special — they have beautiful

embroidered buttons and edging.

Bernie de Le Cuona's talent for fabric is
apparent in this sensual combination of bedcovers.

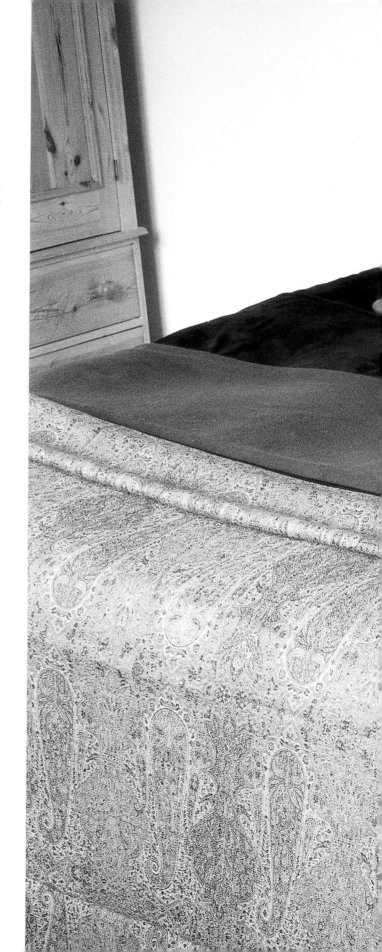

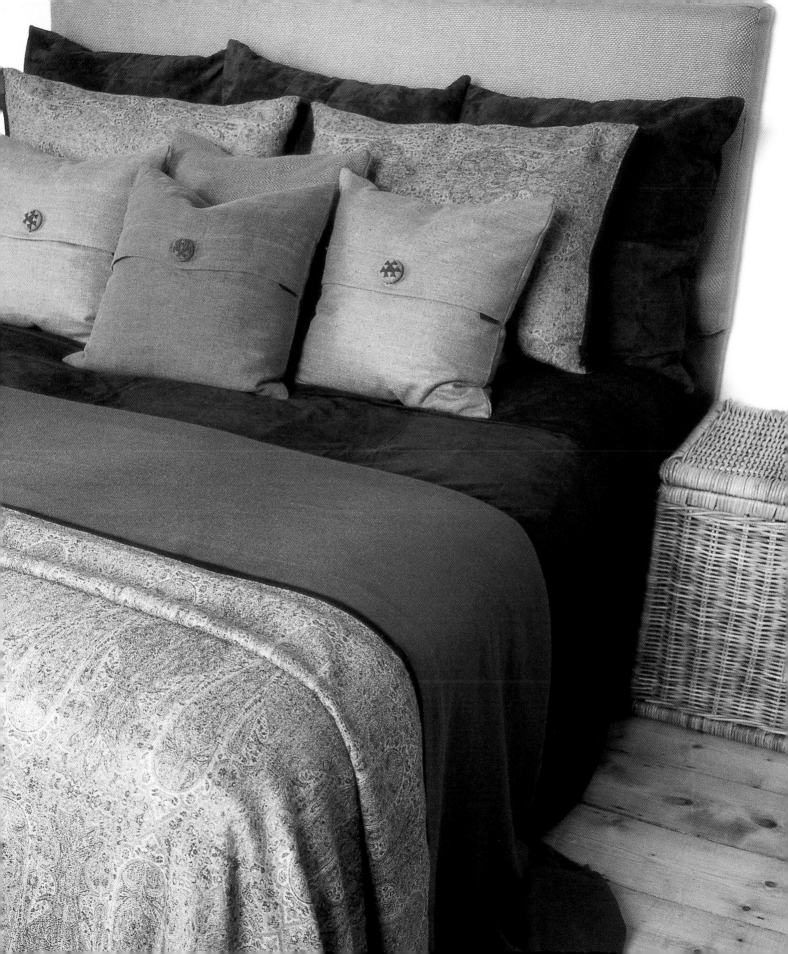

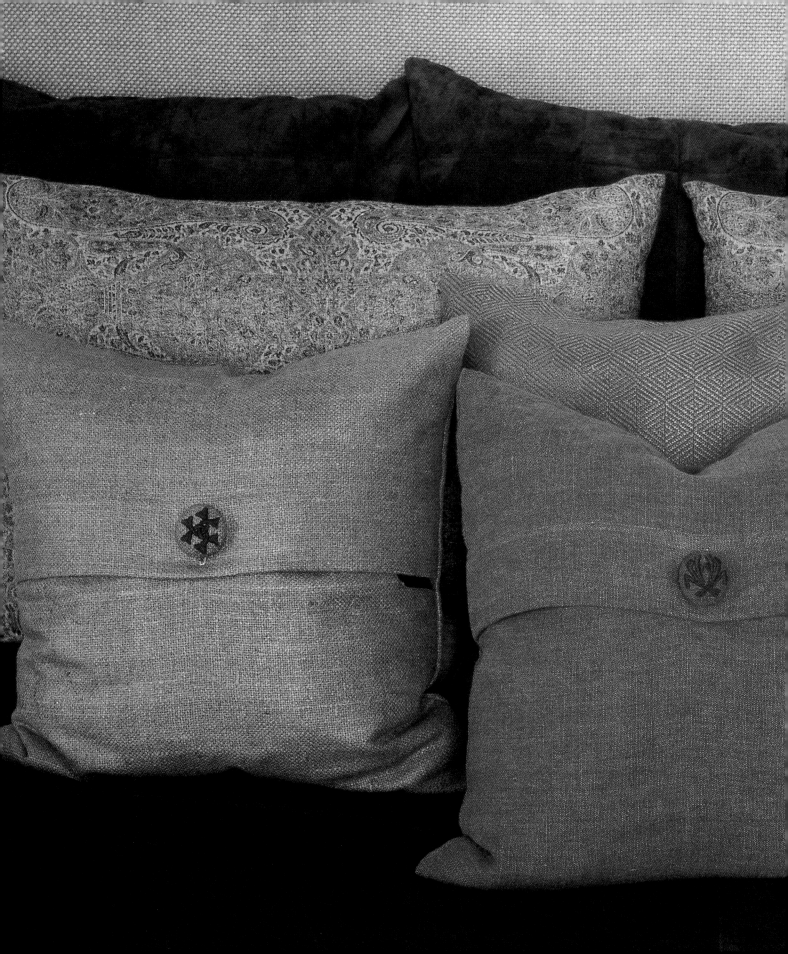

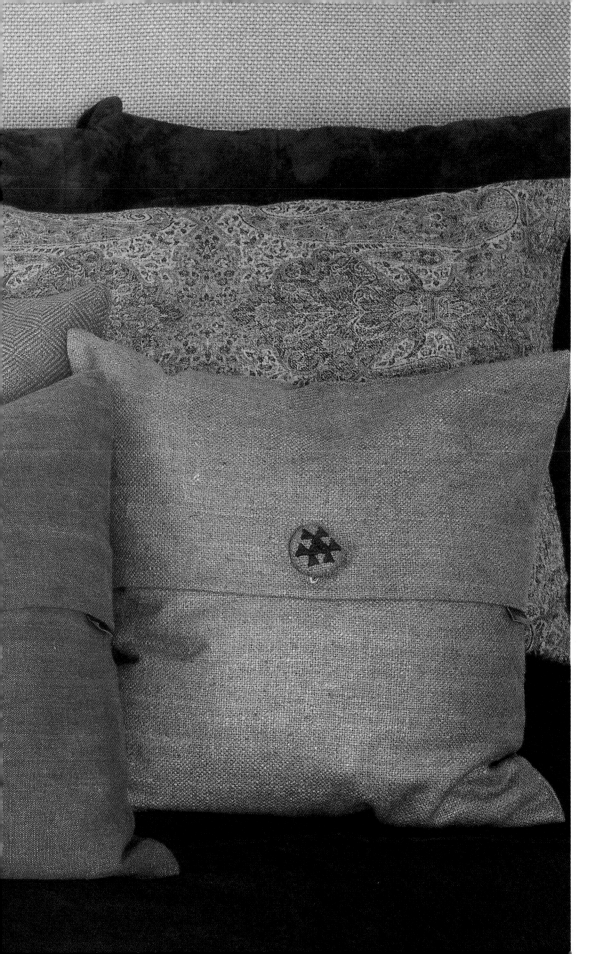

A close-up of the
cushions on Bernie de Le
Cuona's bed shows how
to combine Classic
patterns, such as paisley,
with a variety of textures
to create a very
contemporary and
luxurious feel. The
bedhead is in heavy linen
and is beautifully plain,
offering maximum
flexibility for changing
themes through the year.

modern

I think that there is nothing so effective as adding ethnic touches to a room if you feel it is looking a little too stark or plain. If you have cutting-edge minimalism in your home, or a naturals-and-neutrals interior, the rich patina of handmade African bowls or the brilliant red weave of Zulu marriage hats will add warmth and vibrancy. The addition of antique or modern artifacts from all around the world — anything from a rough Indonesian bench-table to a glorious piece of Chinese lacquerwork — adds texture and variety.

left: This sample board was painted by Marinella Angelini and Maria Pia.

below: A watercolour by Parisian artist, Michel Lablais.

Travelers have always collected beautiful objects and brought them home, and, as the the same international branded products can be found on the streets of Tokyo, London, and New York, items made with traditional skills out of natural materials are increasingly valued. And if you buy contemporary craft, you also have the satisfaction of knowing that you are keeping traditional skills alive. Many humble pieces have as much presence and beauty as any work of art, as I discovered when I visited the homes on the following pages.

ethnic

above: This wooden Chinese
apothecary chest holds glass baubles.

below: A ceremonial hat from Cameroon
made of coloured feathers.

Many of the houses you see here are in South Africa, but there are also ethnically-influenced interiors in Britain and other parts of the world. You can enjoy the modern ethnic look wherever you live and it isn't expensive either. Collectors, such as Steven and Juliette de Combes, whose home is on page 71, buy simple bowls as well as more striking tribal art, which they use in their home for holding anything from sunglasses to socks. Even their dog eats out of a double wooden food bowl from Western Zambia rather than an ordinary petfood dish. Steven and Juliette are dealers in tribal artifacts, and they also create displays of the objects, advising clients on incorporating African art in their homes, as well as travelling to remote destinations around Africa in search of traditional handcrafted work. They not only pay for the items they buy, but they also replace them, so that the people in remote places aren't left without essential household items. I spent a wonderful day with them in their house in Scarborough (South Africa.) It was a former fishing cottage, which they have restored and now houses their extraordinary collection of African art, which they buy both for themselves and for clients all over the world. Every piece is part of their lives, and they can tell you everything about the adventures they had to track it down.

Juliette has been a fan of red as a backdrop to ethnic furniture and displays for seven years. Since there was no fireplace in the house, she wanted a feeling of warmth, and mixed the rich, ochre red herself to get exactly the shade she wanted. When I first saw a photograph of her red room, I realized it was a room that absolutely typified what I wanted to talk about in this book.

However, you don't have to live in a fisherman's cottage in Africa to get this look – Bernie de Le Cuona's home in England, featured on page 64, shows you how you can mix ethnic items with sophisticated modern furniture in a sitting room anywhere to achieve a highly individualistic look. Bernie de Le Cuona suggested we hang these bright ochre-dyed Zulu marriage hats (see left) in a contemporary drawing room to add life and colour.

One of the keys to using ethnic artifacts is to adapt them to twenty-first-century living. Rugs and shawls can be turned into hangings and rough-hewn benches or stools into coffee tables. Like Steven and Juliette de Combes, you can use clay pots, trays, and handmade baskets for filing receipts, keeping keys, or kits for polishing or sewing.

left: Red Zulu marriage
hats, with wooden staffs
sourced by Linda Bird.

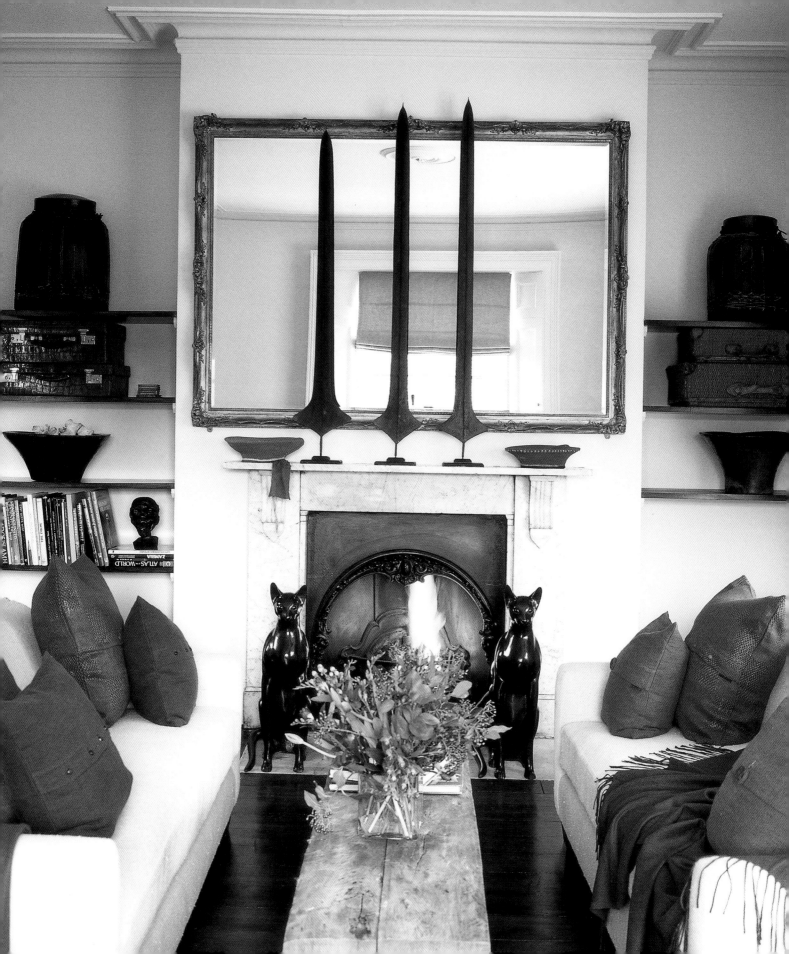

interior
interest

Bernie de Le Cuona's drawing room shows

how you can combine traditional furnishings

and tribal art to create a stunning, and still

comfortable, interior. The sofas on either

side of the fireplace and the mirror over the

mantelpiece are Classic in design, yet

when combined with African

spearheads, red Zulu hats and a rough

wooden Indonesian bench as a coffee

table, the room acquires zest and

originality. She's used texture rather

than pattern to add depth, adding

linen and suede cushions and a woven

alpaca throw from de Le Cuona

fabrics to a linen-covered sofa.

below: In a formal drawing room, a wooden bench adds more interest than a standard coffee table, and offers a contrast in texture to the soft fabrics.

left: Two antique bronze cats from Sotheby's add drama to a fireplace decorated with three African spearheads and the red hats worn by married Zulu women. The sofas are covered in handloomed silk, and the throw is made of alpaca.

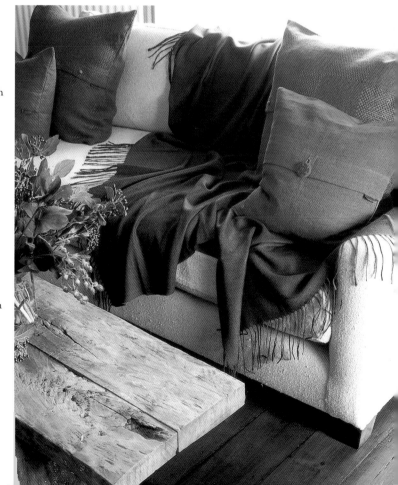

earth

reds

A close-up of the room featured on the

previous pages shows the sure eye for

combinations of texture and colour that has

made Bernie de Le Cuona's fabrics a must

for decorators everywhere. French linen

curtains with wool embroidery are given body

with a heavy interlining and then contrasted

with a softly sensual linen velvet blind. Two

sculpturally elegant African drums complete

the scene. Combining a blind with curtains

provides a practical and decorative solution.

I discovered this umbrella from an Indian

howdah in Guinevere's showrooms in

London. Its extraordinary burnt-red patina —

dulled over the years — looked wonderful next

to the bright, bright red tulips.

left: The curtains of the
drawing room are made
from French linen and
contrasted with a linen
velvet blind. All the fabrics
in the room are from
Bernie de Le Cuona.

below: The umbrella of
an Indian howdah is
positioned on the floor
next to a wonderful
flower display for a
striking effect.

Suede and leather have crossed over from

fashion to the home and can be used in many

unusual ways. Leather, in particular, has

moved away from its harsh masculine image,

and is now being used as a furnishing fabric

alongside cottons and linens. Choose subtle

colors, rather than the ubiquitous black. Suede

is softer and has more texture, and for those

who worry about its wearability, there are many

excellent faux suedes which are also washable.

Here Bernie de Le
Cuona's red suede throw
drapes beautifully over a
sculptural Japanese chair
that has been carved out
of one piece of wood.
Behind it another unusual
fabric – ostrich skin – is
used to cover a stool that
can be used to perch
drinks, books, or a
telephone, or which can
double up as extra
seating.

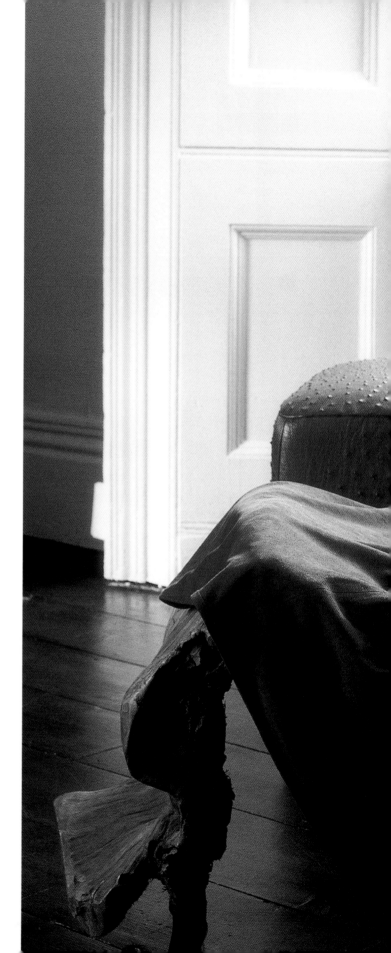

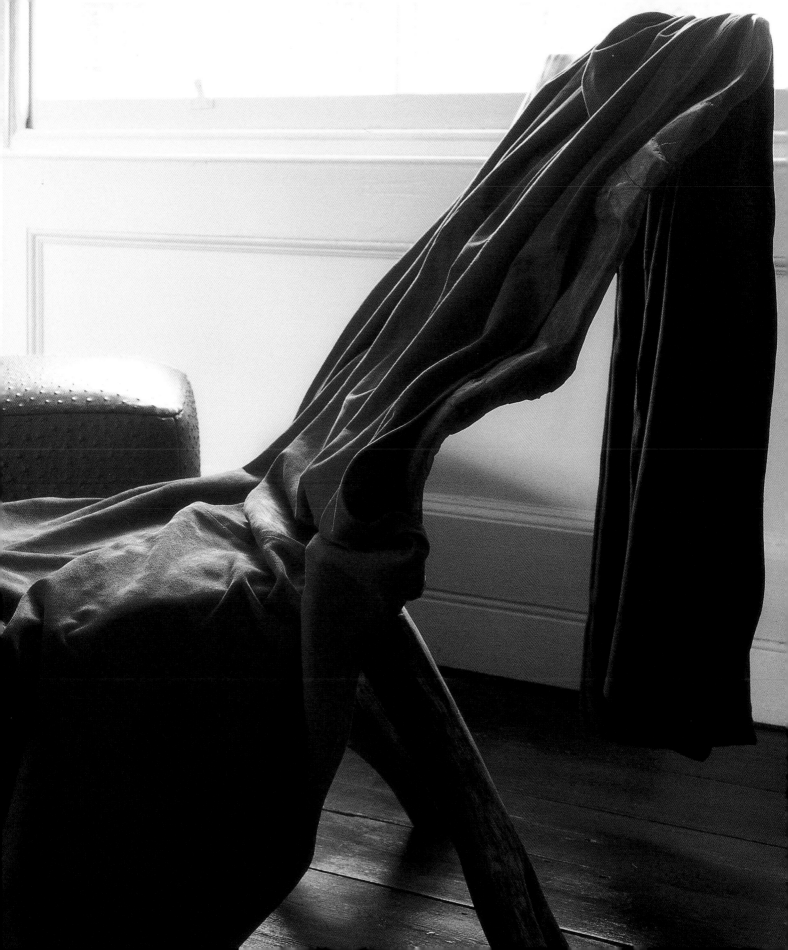

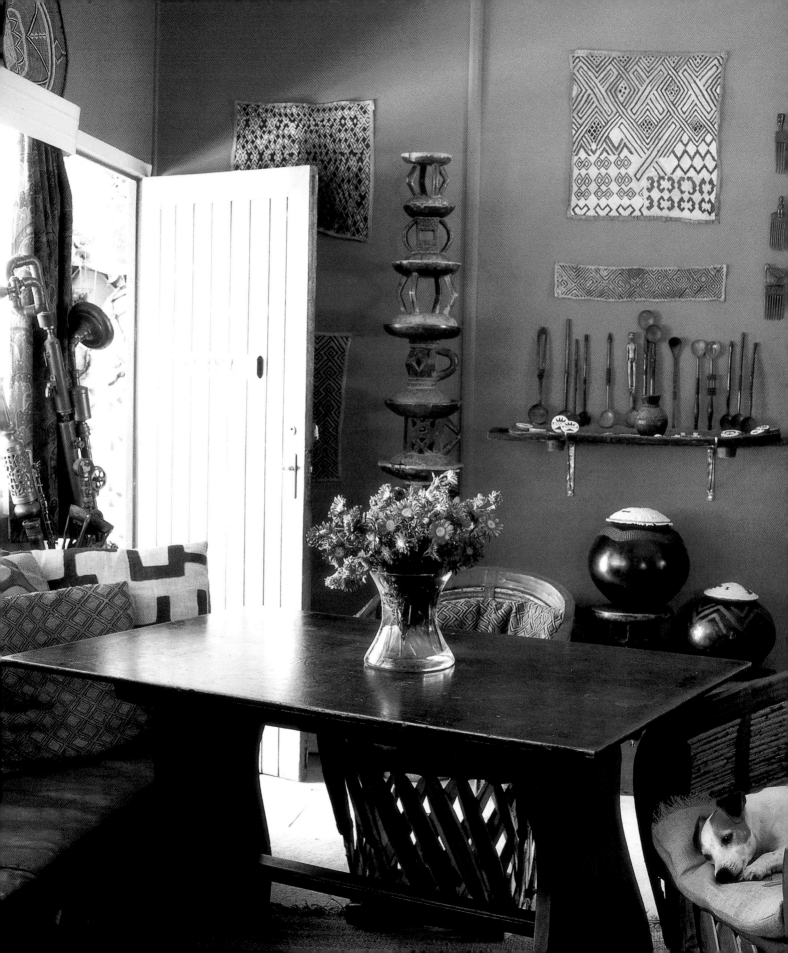

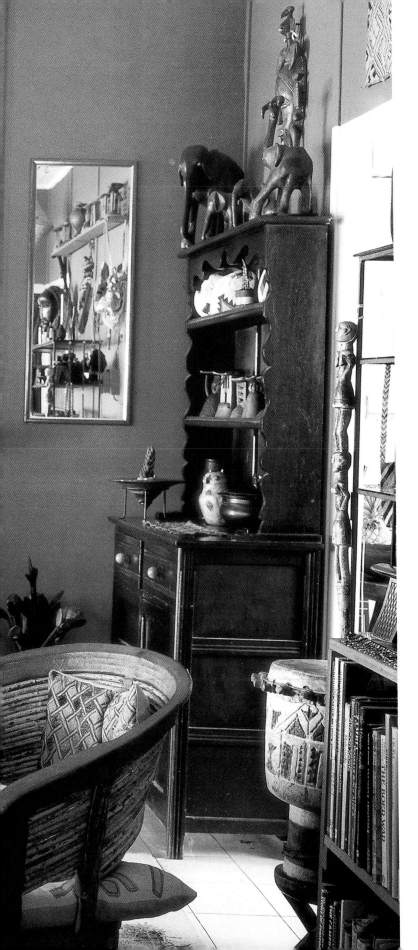

out of Africa

Dealers and collectors of African artifacts, Steven and Juliette de Combes, have created a truly eclectic home. Hide and willow furniture from Mexico complement wooden stools from the Tonga, Tshokwe and Lozi tribes in Zimbabwe and Zambia. The wall hangings and some cushion covers are Shoowa Cloth from The Kingdom of Kuba in Zaire.

Under the mirror is a Zulu milkpail filled with horn spoons, and on the dresser are Zulu beaded beer pot covers, Himba headrests from Northern Namibia, and a "zoomorphic" owl pot from Western Zambia.

Steven and Juliette de Combes' home combines African artifacts with elements from all over the world.

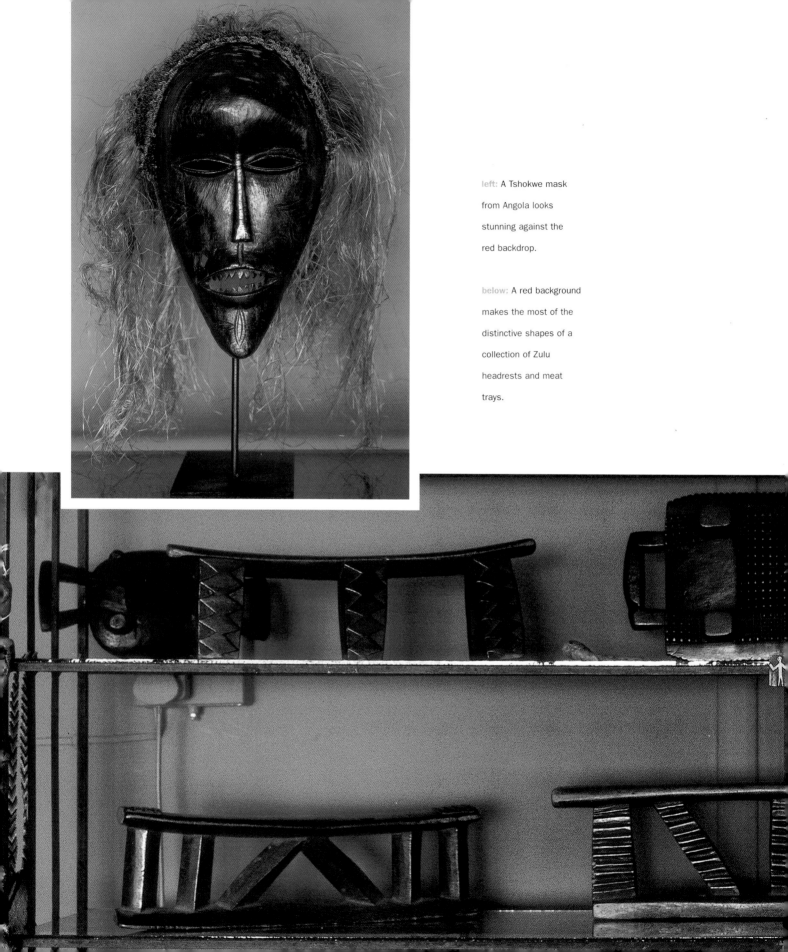

left: A Tshokwe mask
from Angola looks
stunning against the
red backdrop.

below: A red background
makes the most of the
distinctive shapes of a
collection of Zulu
headrests and meat
trays.

I love the rich patina of these tribal items collected by the de Combes. The drama of their wonderful collection of Zulu headrests, snuff containers, ritual masks, combs, and wooden objects is a great example of how red makes a perfect background for collections. These shelves show a very effective display of artifacts (unless stated all are Zulu:) from left on the top shelf is a small meat tray, six-legged headrest, a pair of bronze Lobi diviner bracelets, from Burkina Faso, and a six-conical-legged headrest. The next shelf down has three Zulu headrests in different designs, including a rare stone one with V supports. The drama of this collection against the background shows red to maximum advantage.

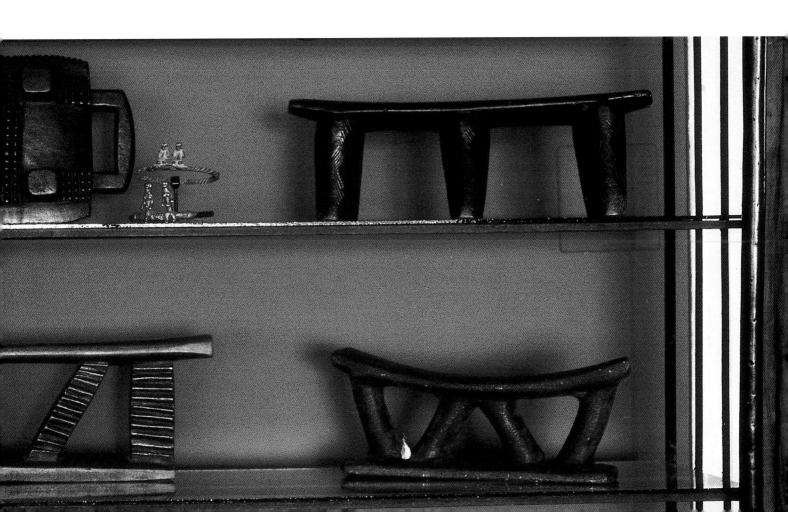

left: Here's an inventive use of saris from Beezy Bailey. The zany red fabric has been turned into curtains, flanking a Chinese red lacquer chest. It's a combination that works particularly well – picking up the colour of a piece of furniture in the curtains can be an effective decorating trick.

right: Sari fabric, with its brilliant colours and enchanting decorative embroidery, can be found inexpensively in Indian shops and markets around the world.

This dramatic painting of Africa, purporting to be of Leaping Zing, Beezy Bailey's fictitious "Chinese sage", dominates a tomato-red drawing room. The impact in this room comes from a few very distinctive items, such as the African head on the left, against a powerful backdrop of red.

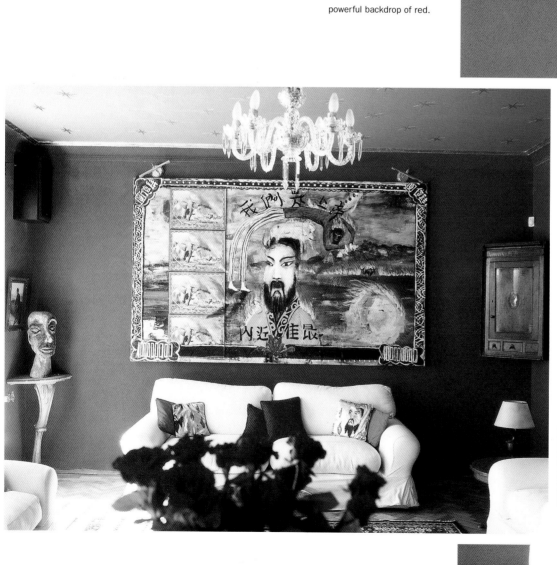

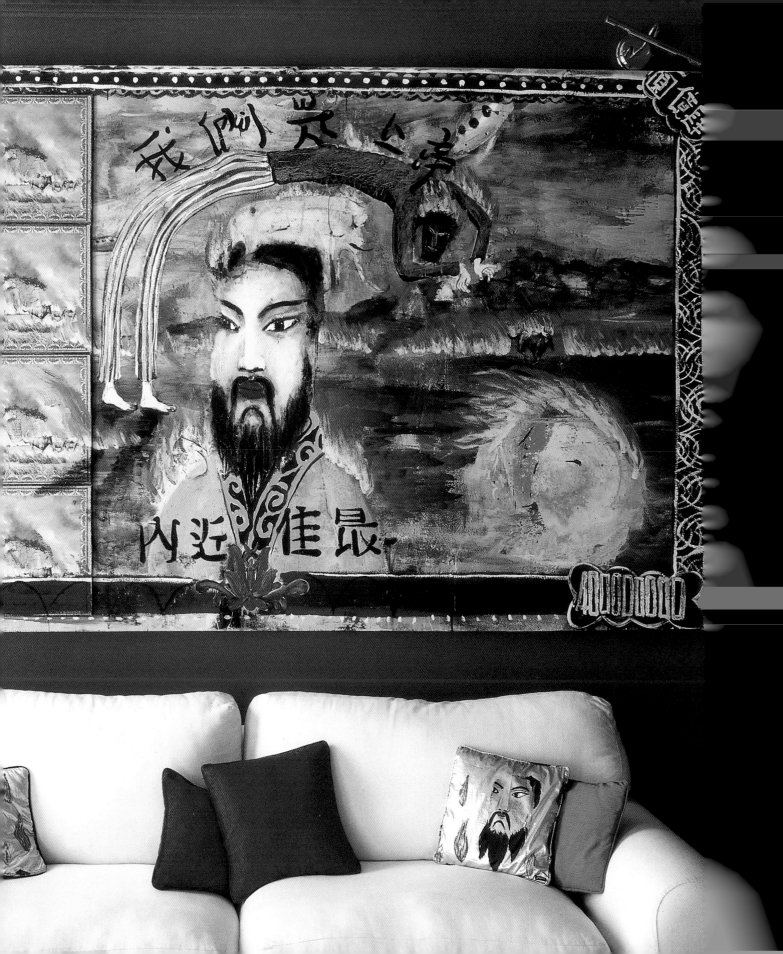

a sense
of style

Talented South African fashion designer

Marianne Fassler uses a lot of leopard-skin

in her work because it's both cutting edge and

typical of South Africa. Here, in her own

sitting room, you can see how the vibrant

black-and-white print works beautifully with

red to create impact. Animal prints are one

of those perennially fashionable elements that

are somehow almost always considered stylish

and outrageous, yet they go on forever. Here

Marianne Fassler's wonderfully eclectic style

is created by mixing modern art, ethnic

artifacts picked up in local markets, gloriously

powerful red walls, and animal print fabrics

on Classic furniture.

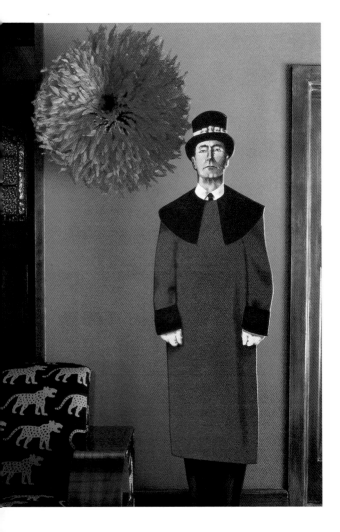

left: An inspiring mix of tradition and contemporary: the cutout figure and the chair covered with animal prints sit stylishly beneath a ceremonial hat from Cameroon. The red walls pull it all together.

opposite: Quirky and original, fashion designer Marianne Fassler, shows how to mix patterns with powerful red walls to create a stylish drawing room for maximum impact.

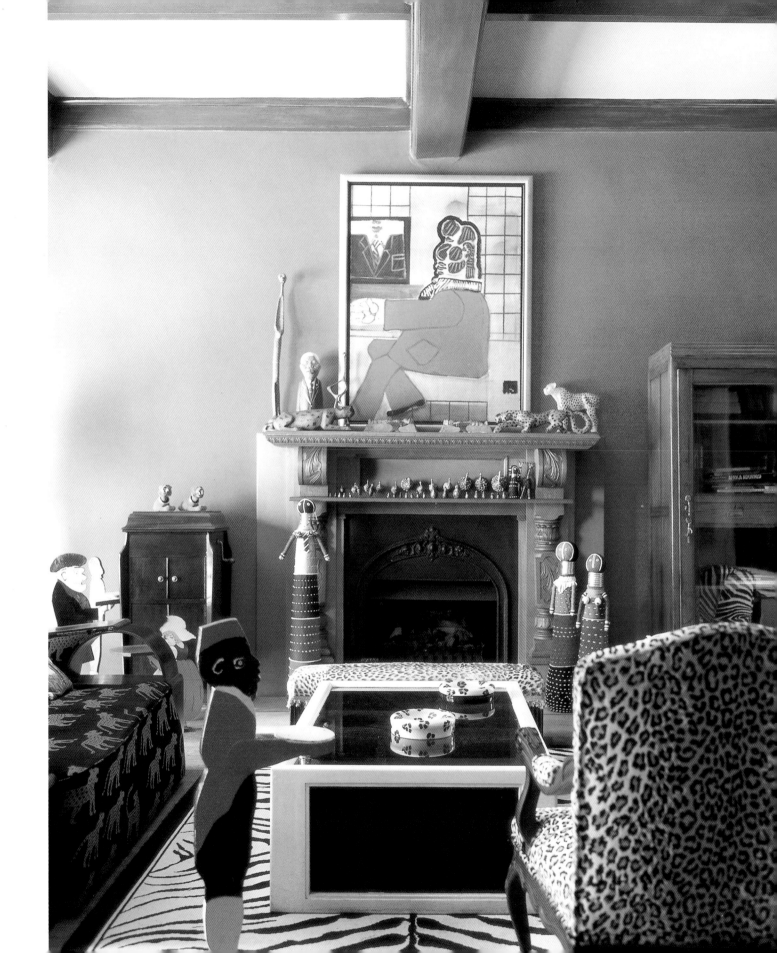

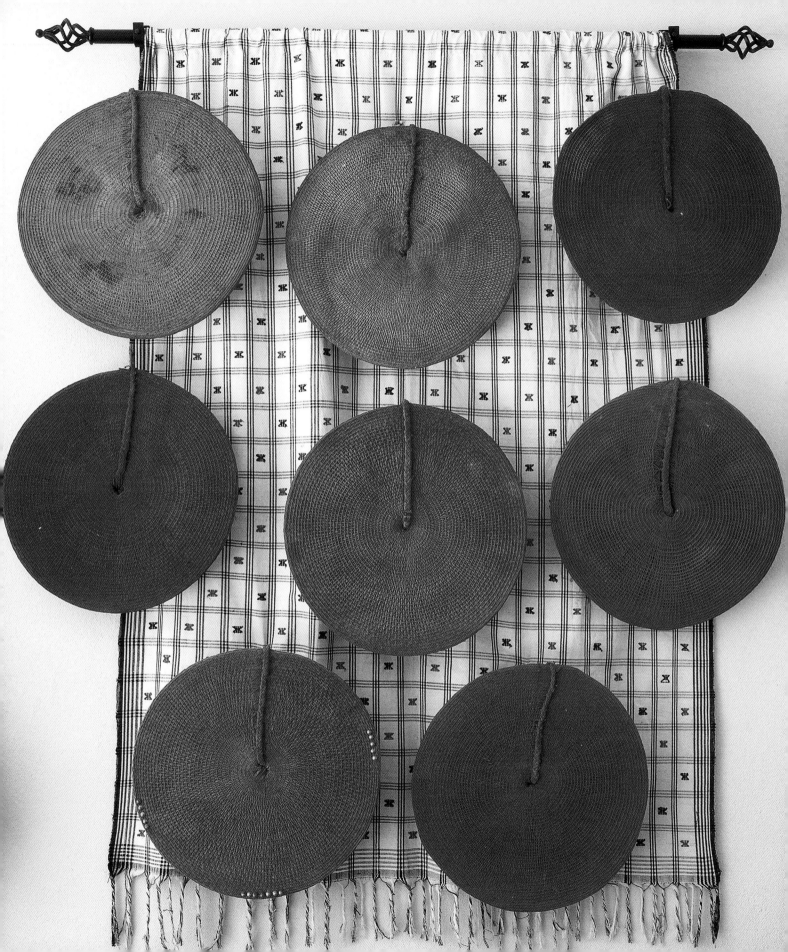

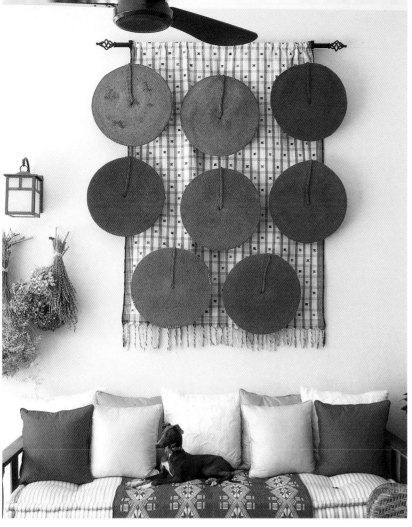

This arrangement of traditional Zulu hats is so stylish yet achievable. The hats are woven from ochre-dyed grass fibres over a basketry frame, and are now mainly worn by married Zulu women for ceremonial occasions. The warmth of the red and their simple shapes make them ideal for display and Liz Fallon has effectively, yet simply, hung them on a piece of checked fabric on a metal curtain pole.

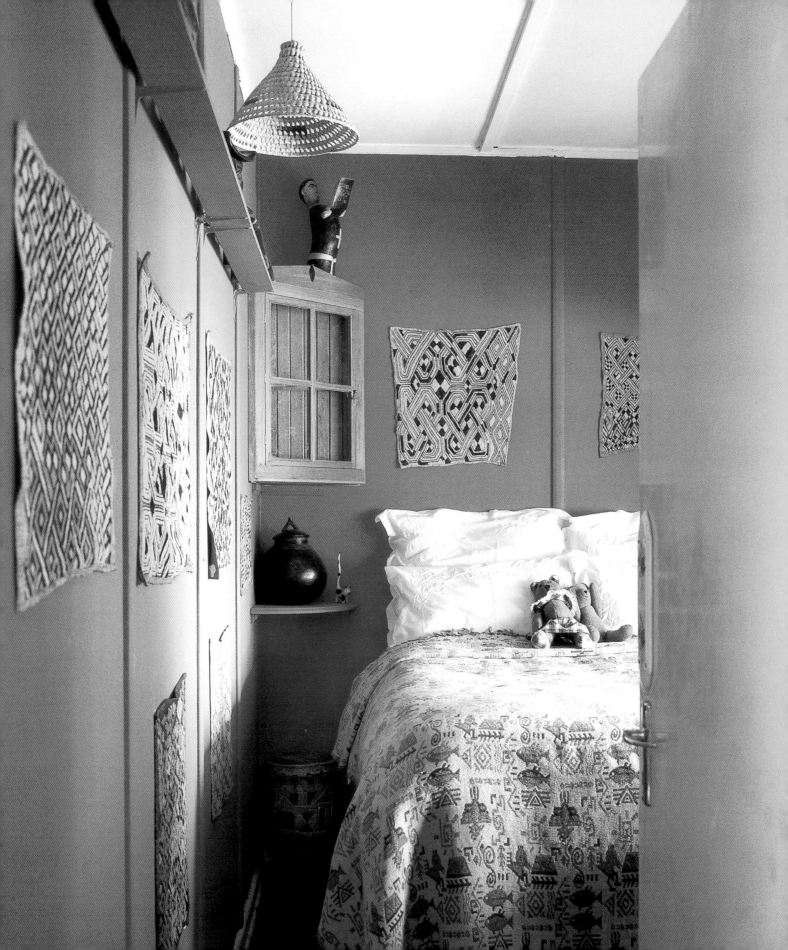

I love subtle reds in bedrooms. This sunny ochre shade is warm and welcoming, especially when decorated by African art dealer Juliette de Combes in a beguiling cultural mix of bold, basic patterns, and abstract designs, with African wall hangings and artifacts juxtaposed with European fabrics like this bedcover, found in a British flea market.

sunshine and sanctuary

left: The hangings on the wall are squares of traditional Shoowa cloth from the Kingdom of Kuba, and on top of the corner cupboard is a contemporary carving, from the Umvoti Valley in Zululand, of a large-bellied priest reading from the bible. Beside the bed is a big wooden pot from the Lozi tribe which was used to store flour or maize, now used to store sweets.

right: The Shoowa cloth hangings displayed throughout the de Combes' house are made of strips of the outer layers of dried raffia. As well as their use as currency or dowries, they were also offered up to the dead in great numbers.

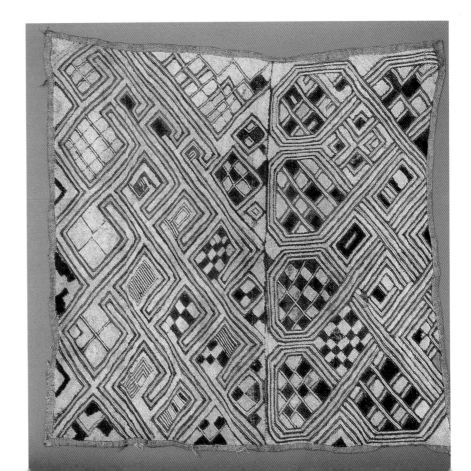

This painting of a sample board by theatre designers Maria Pia and Marinella Angelini evokes the clashing pinks of pure gypsy excess.

When I first thought of this book, I was convinced that the pretty, gypsy styles I saw on the street would soon be fashionable, and as our plans evolved, it became obvious that this is one of those trends that begins spontaneously and is picked up by the fashion designers rather than the other way round. Vivid clashing pinks and oranges and the eclectic mix of patterns soon began appearing in couture clothing and in little fashionable boutiques in chic parts of New York and London. It wasn't long before embroidery, beading, lace, and tassels, along with pretty little bags and baskets, appeared in mainstream stores, as this fun, feminine style appealed to people who were already beginning to get tired of minimalism.

This look is an easy mix-not-match style that shouldn't cost too much money, and gives you the chance to experiment and develop your own style. Many of the homes on the following pages were decorated on a shoestring but they all emanate a great sense of style. Think of everything you own as a potential work of art.

style

above: This reverse glass painting of a gypsy marionette is by Marie Amalia.

I believe that the divisions between art, fashion, and the home have now disappeared. Anything that catches your eye, such as a beaded bag, can be hung on a wall as art, and clothes, such as scarves and shawls, can turn into furnishing fabrics by being thrown across sofas and the backs of chairs when you're not wearing them. Twist glass bead necklaces or fairy lights around mirrors and picture frames, and hang your favourite party dresses on the wall.

This is a particularly good approach for displaying collections — instead of keeping beautiful beaded and jewelled evening bags tucked away for nine-tenths of the year, display them on a wall in any part of the house. Hats, too, deserve to be shown off more — rather than just taking them out for special occasions, turn them into works of art. And, of course, for those who collect textiles that they don't wear, such as ethnic or antique clothing, this approach is perfect.

You can layer textiles, bags, and clothes for a rich, colourful look, like the wonderful hanging shown right with a Turkish costume on top of it. It's very simple but looks amazing.

You don't have to adopt the whole gypsy style. Just one or two elements added to your current room can be fun. A pleated Fortuny-style dress, a Chinese kimono or tribal costume hung on a wall would add a contemporary touch to a bedroom or dressing room.

There are many clever decorating tricks on the next few pages that are particularly useful for those who want to achieve a dramatic look on a budget — the Bedouin tent effect on page 88 is created with cotton sheeting, and the stairs in Shari Maryon's house are covered in oilcloth table covering, for example. Brightly coloured paint and junk-shop finds are at the heart of the style, making this look accessible to everybody.

opposite: Suddenly clothes as homestyle accessories are emerging everywhere.

left: Annie Khan's inspired combination of architectural palm leaves and roses is a perfect addition to a gypsy-style room.

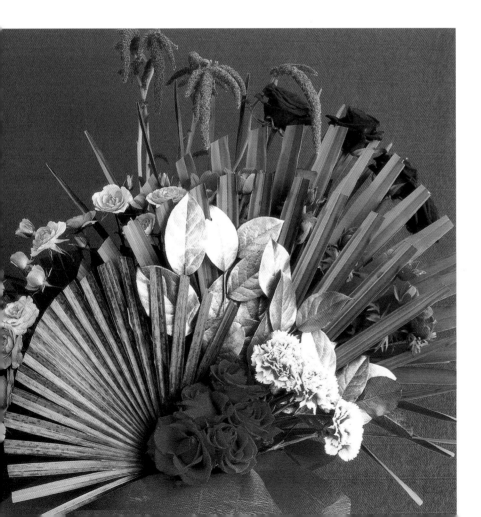

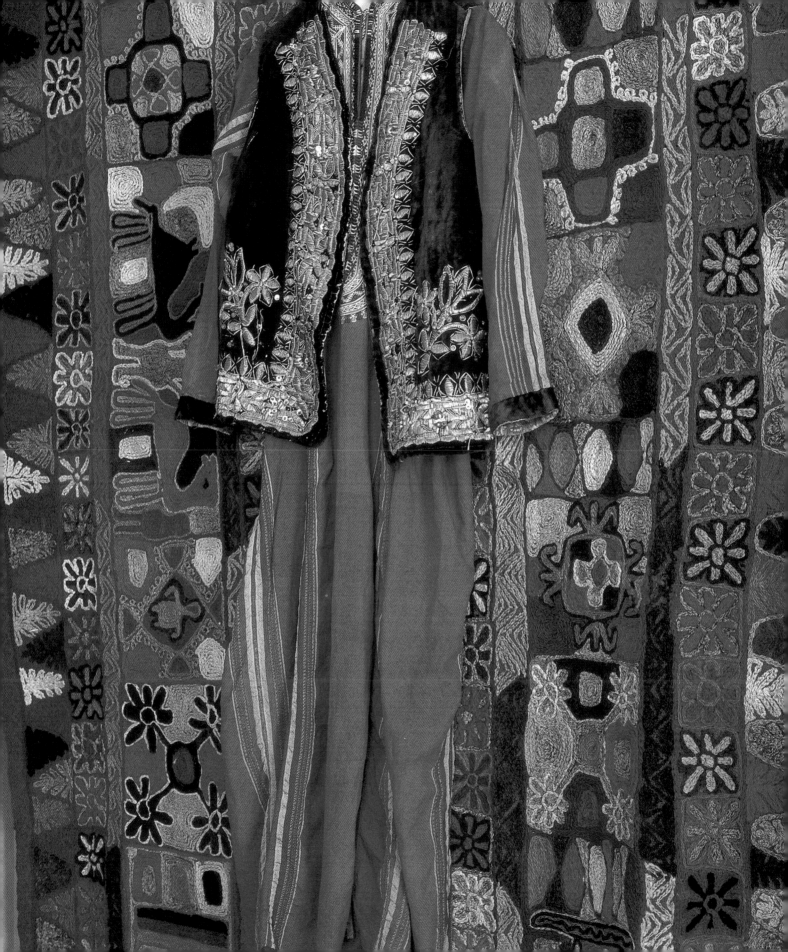

Bedouin chic

When considering this book I imagined a glorious red room with all the tented exoticism of a gypsy caravan or a Bedouin chieftain's tent. I'd never seen such a room, but I knew it existed, and while shooting at Beezy Bailey's house, I met the hugely talented muralist, Mario Lucangioli. He told me he had just finished decorating a red room. We called in and it turned out to be the Romany, Bedouin, 1001 Arabian Nights room of my dreams.

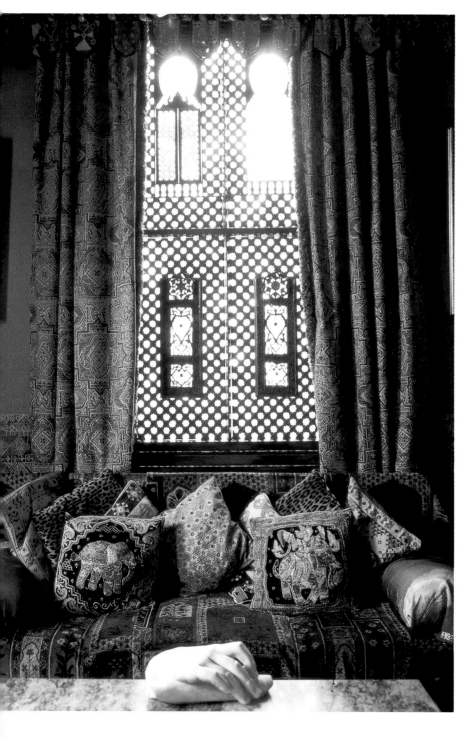

left and far right: The tenting fabric is inexpensive patterned Bokhara sheeting, and the wooden shutters offer privacy while allowing light through.

below: Attention to detail need not be expensive: these bells were sewn on by the muralist, Mario Lucangioli.

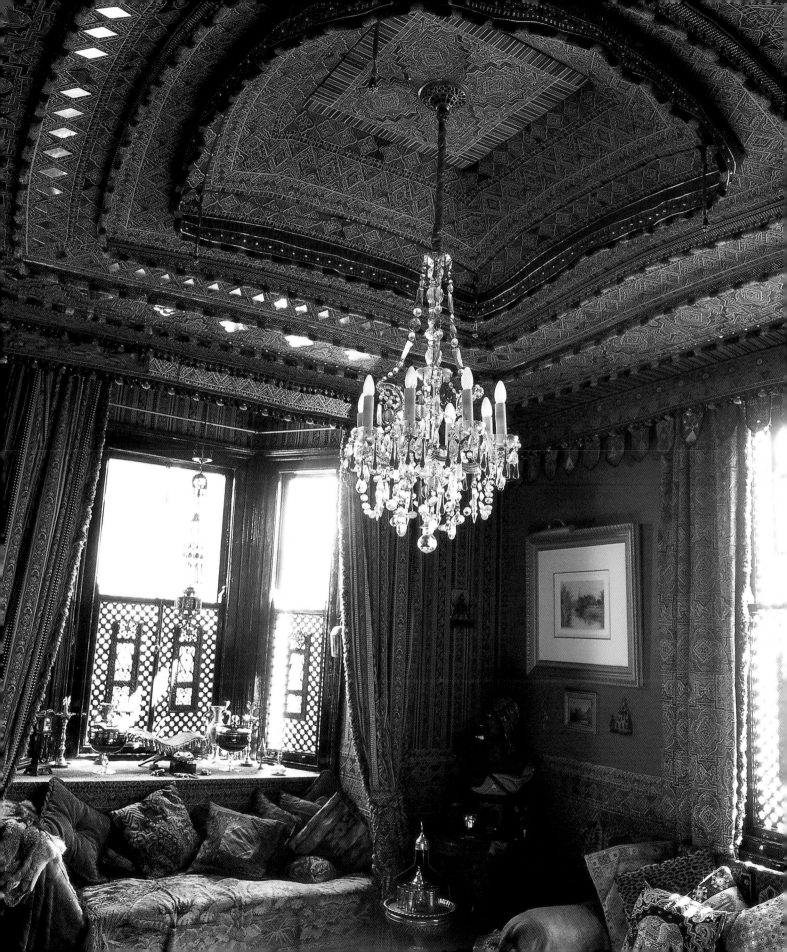

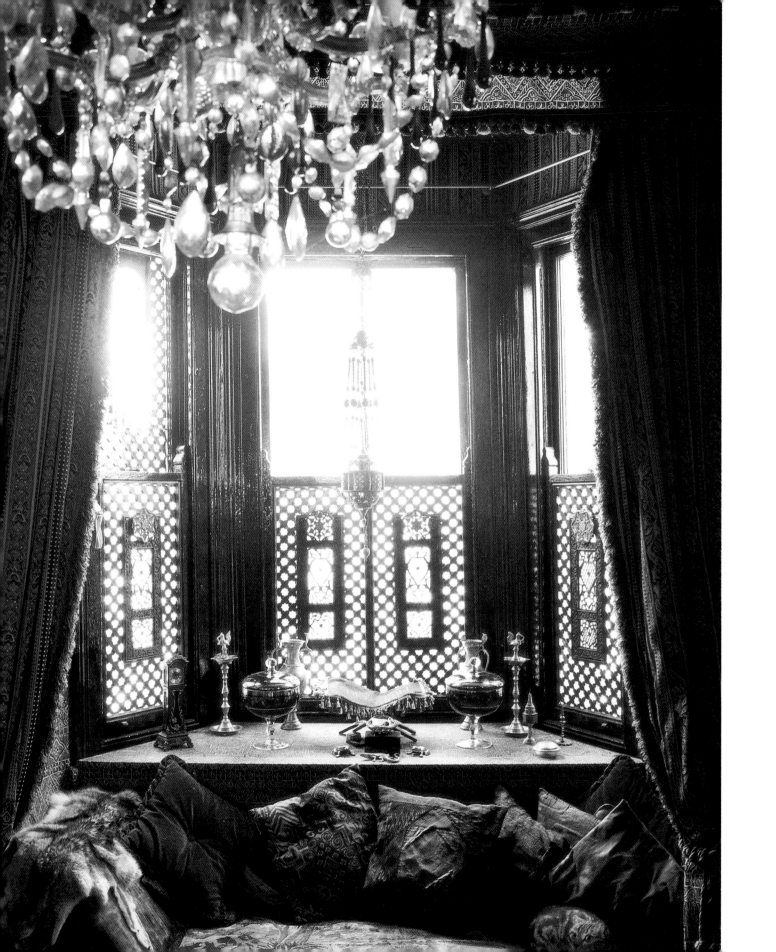

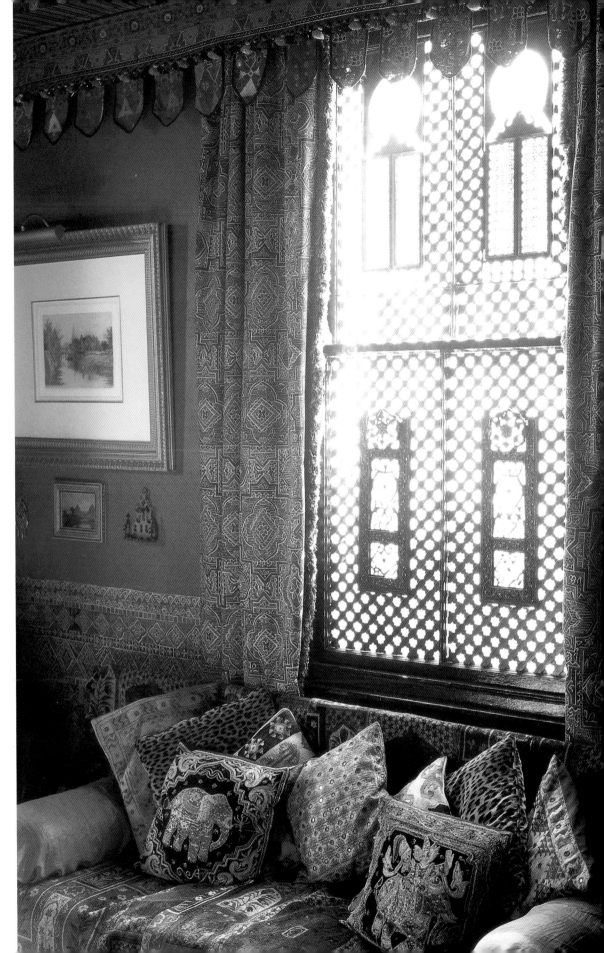

left and right: Although this room seems almost impossibly exotic with fabric on the walls and a tented ceiling with mirrors and bells sewn on, it is actually very achievable. The house itself looks like a palace from these photographs, but is actually only a small workman's cottage. The fabric is patterned Bokhara sheeting, and not at all expensive, and latticed shutters can easily be made by a carpenter for any kind of window. These would make a good alternative to voiles when privacy is an issue. Piles of cushions and lots of sofas are essential to the look – this Moroccan or North African look is very fashionable at the moment, and is comfortable too.

wild
interiors

What I love about this colourful, bohemian look is that it started with street fashion, moved to the catwalk and is now mainstream in both fashion and the home. It's fun, quite girly, eclectic, and isn't expensive to achieve. Shari Maryon, whose home this is, collects everything from flea markets, junk shops, and High Street sales, and because she paints all her walls herself, changing the decor of her rooms costs only the price of a pot of paint.

right: The chaise is covered with antique eiderdowns but the dress on the dummy was a sale bargain. Shari frequently wears it. The little shelving unit is made of medium density fiberboard from a hardware store, and is painted and hung with red heart fairy lights.

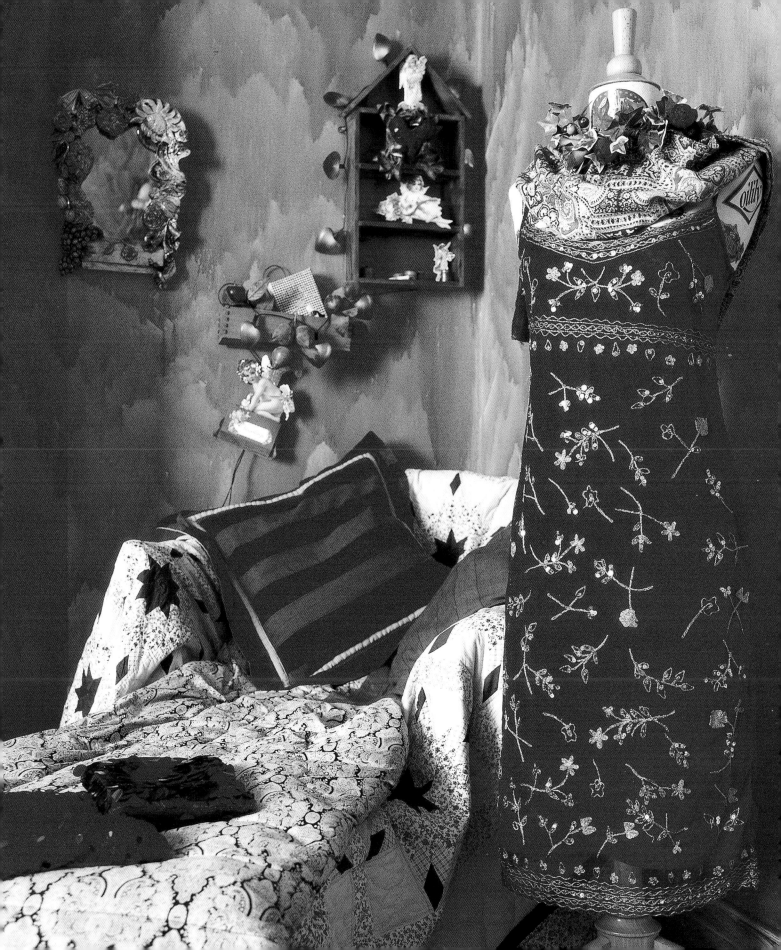

colour
and pattern

Shari Maryon developed her exuberant use of colour by experimenting – many of her rooms have been repainted six or seven times in as many years. She uses water-based paints in strong colours, and then dilutes them a little more in order to get the vibrant colours she likes without the dominating effect of matt oil paint. She paints all her patterns freehand and her only rule is that nothing should ever match. She not only loves mixing colours but also patterns, combining florals, stripes, patchwork, and embroidery in a glorious riot of gypsy colour. There is lots of fun here with trompe l'oeil – cats' heads on the chairs, the rabbit hutch, and even the wellington boots.

far left: Shari paints the walls, the ceilings, the furniture, and even heating fixtures. She adds glittery Indian saris over chairs and cupboards.

below: A recently built cupboard is stacked with Shari's collection of 20s and 50s china, because the bold colours and kitsch designs look great in the mix.

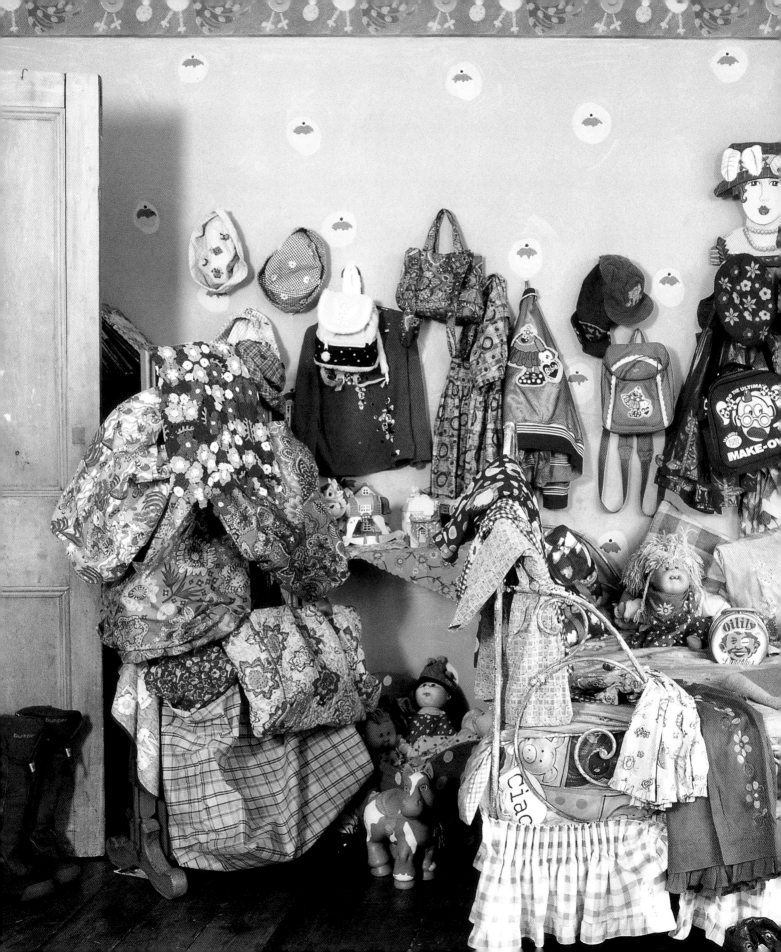

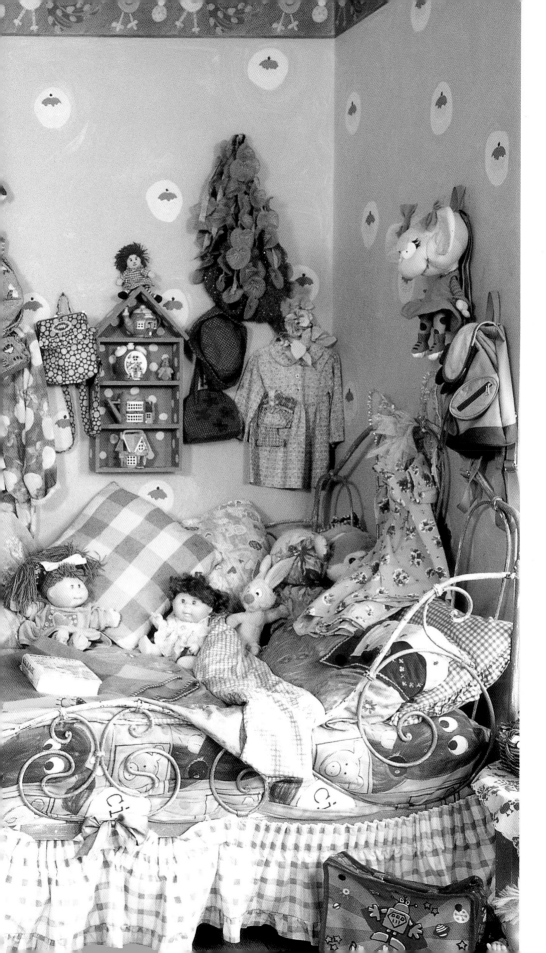

Shari Maryon's daughter's room contains a French cot bed found at a flea market and piled high with cushions and her daughter's collection of rag dolls. Hats and brightly coloured bags, many from Oilily, a children's clothes company whose mix of colour and pattern has inspired Shari, are part of the decor.

decorating
with clothes

This shows how effective the merge between home, fashion, and art can be. Suddenly clothes as homestyle accessories are emerging everywhere. Costume vintage clothing, handbags, and ethnic throws can be used together or singly to provide exciting decoration. This way you can enjoy the colours and fabrics of clothes when you are not wearing them.

left: Shari Maryon hangs her clothes in the hallways on all four floors of the house, against a spotted backdrop which she painted herself.

right: The children's coats and hats make a colourful pile in the stairway. The stairs are covered in the oilcloth that is used for wipeable tablecloths, which is cheap and hardwearing.

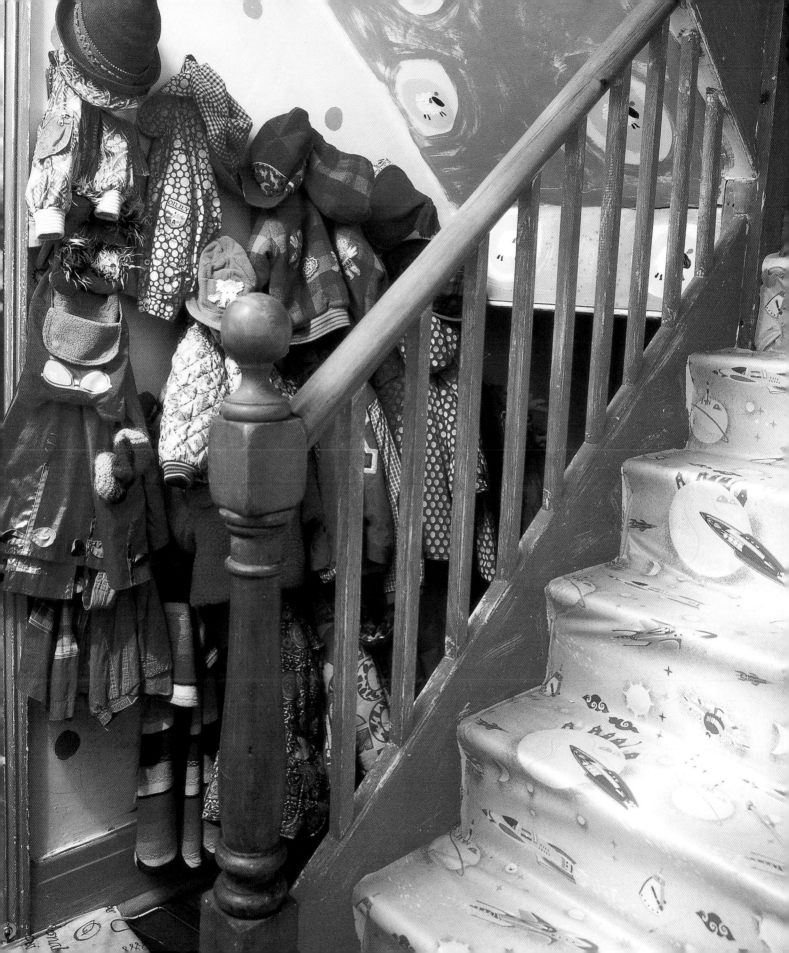

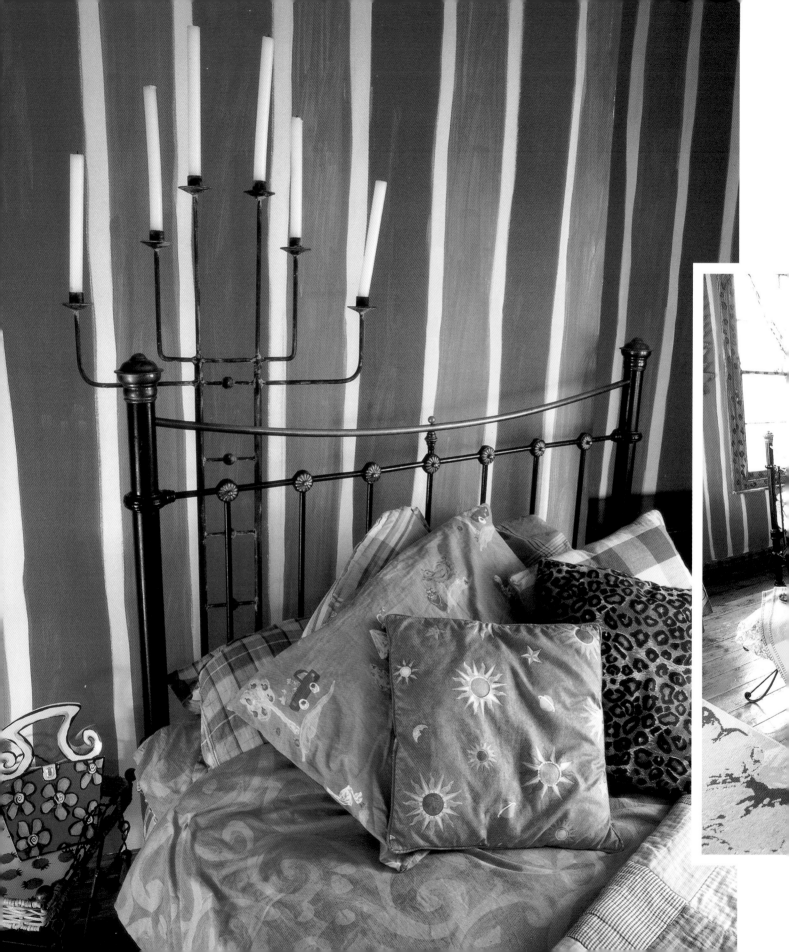

dreaming
of stripes

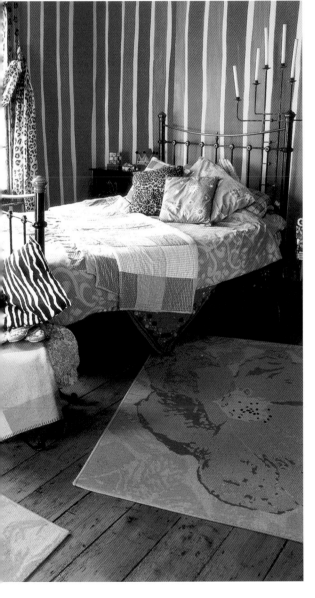

I think stripes are a brilliant way of using reds

and pinks – they can be as conventional, as

classic, or as wild as you like. They can be

broad, narrow or irregular, bought off the

peg as wallpaper or fabric, or you can

handpaint stripes in lots of different ways.

The ones on this page, painted freehand by

Shari Maryon are so wavy that they're almost

like fabric, while Shane Petzer's stripes on

pages 102–103 are more disciplined.

Stripes combine well with each other and

checks for a chic look, or with fabric prints to

create a wilder style.

The bed in this room is from a junk shop and the rugs on the floor from a chain store, so it's a very accessible style to achieve. The stripes are painted freehand, one colour at a time, allowing each to dry before adding the next colour. Piles of cushions, none of them matching, complete the whole look.

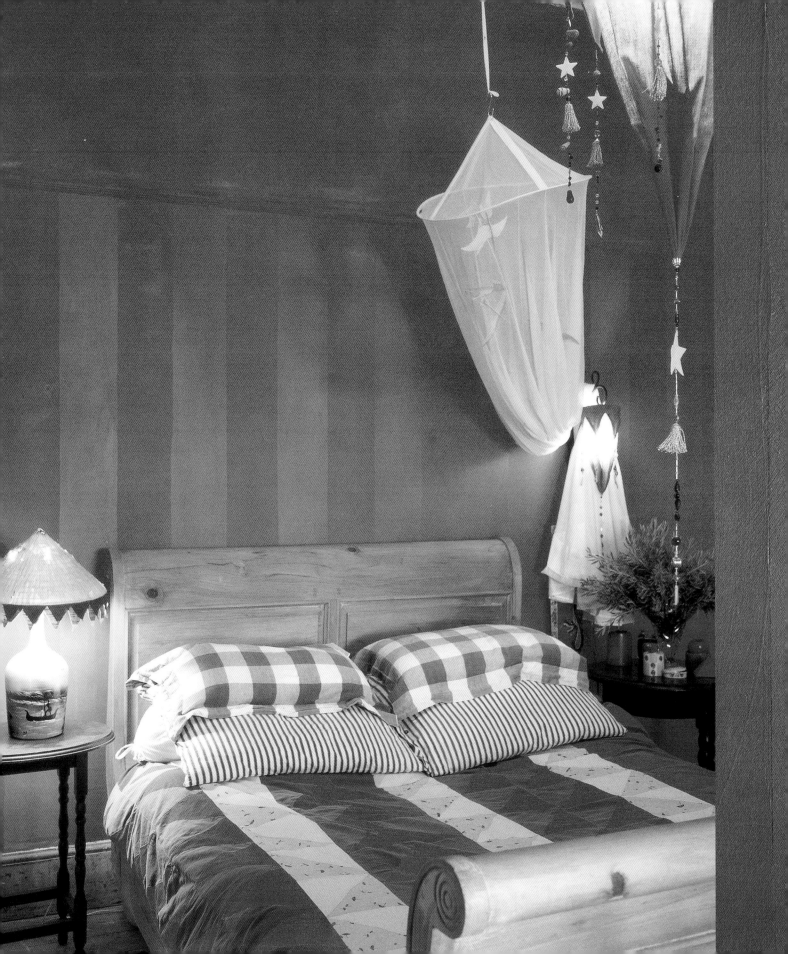

below and left: The stripes on the wall make the perfect backdrop for the fun lamp and the collection of religious artifacts.

left: I love this great, funky young look from the delightful Shane Petzer and Scott Hart, who have painted the walls in wide stripes of red and orange over layers and layers of tissue paper, which gives the wall a wonderful texture. All the lights in the house are creations of Magpie Fine furnishings and Homeware, Shane and Scott's decor business.

in the
pink

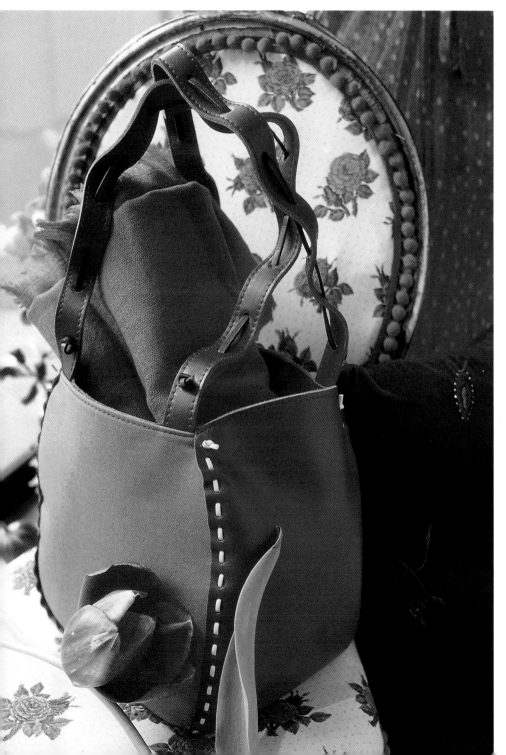

These lovely cushions and bags in zingy reds and pinks are what finally convinced everyone that the gypsy style is now a major trend. We found them in the directional London fashion boutique, Whistles, owned by Lucille Lewin, where I realized that my instincts, about the way fashion and homes now feed into each other and about bohemian gypsy style, were correct. Whistles is where fashion and the home meet — almost anything found in the store would look wonderful in a room.

left: I can't stress too much how effective it is to use accessories as part of your home decoration. This bag from Whistles is too gorgeous to be hidden away.

right: Fabulous fringeing, exuberant patterns, and delicious shades of pink make these cushions from Whistles irresistible.

Art Deco
pink

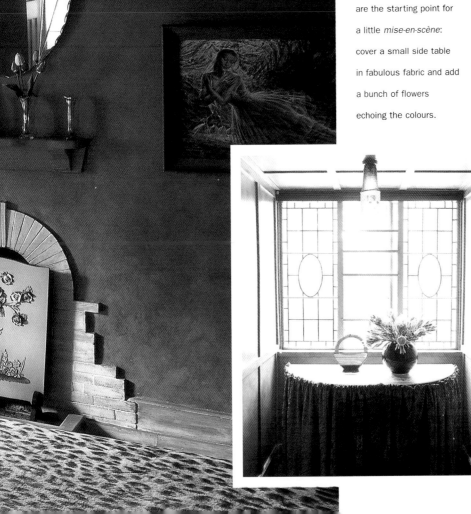

left: I adore this bright flamingo pink that Marianne Fassler has used for full-on glamour in her bedroom.

below: The typical 20s stained glass windows are the starting point for a little *mise-en-scène*: cover a small side table in fabulous fabric and add a bunch of flowers echoing the colours.

Fashion designer Marianne Fassler mixed this flamingo pink and purple paint effect in a top-floor bedroom in her 20s home to go with the paintings by Tretchikoff on the walls. This is gypsy style without the clutter, combining a few carefully chosen eclectic elements: leopard-skin prints, an Art Deco mirror, and pieces of African craft.

If you want to re-create this kind of look, decide on just one or two very strong elements and keep it very disciplined. There is only really one colour in this room, but it is over both walls and ceiling. Similarly, the leopard skin is on both chair and bedspread. Choose a few extra touches carefully.

right: Marianne Fassler wanted a "magical" light source in this eclectic room, because she felt that minimalist lighting just wouldn't have worked. The jeweled standard lamp on a wavy stand was made by a local artist.

far right: Marianne Fassler has become associated with leopard-skin, because it is both fashionable and a typical African design, and she is emphatic that her work is evenly balanced between being thoroughly contemporary and inspired by Africa. The paintings are by Tretchikoff.

right: Marianne Fassler mixes art and craft with finds from secondhand shops: this wonderfully warm and delicate lamp was a lucky find in a junk shop, and is an enchanting addition to the room.

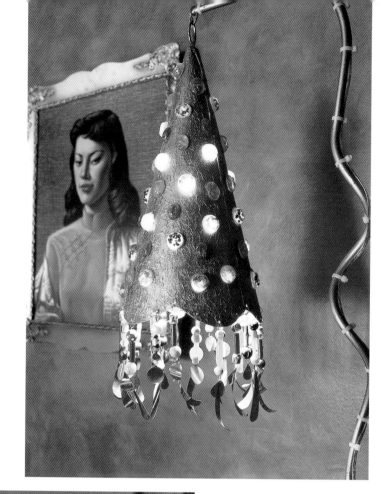

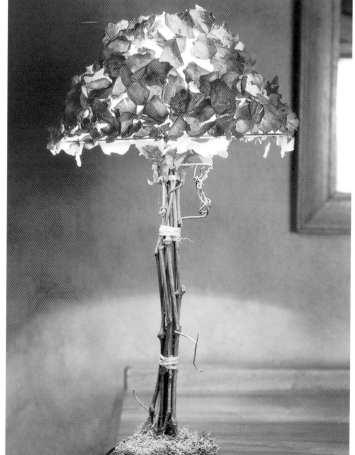

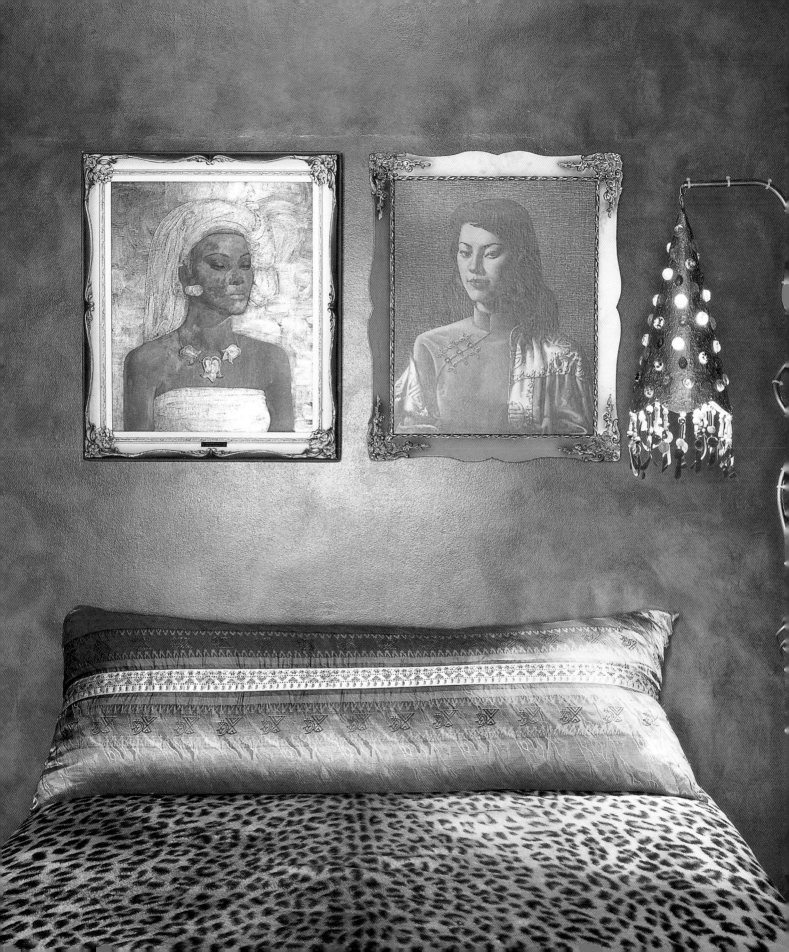

left: Marianne bought this beaded curtain in the Seychelles. It probably originated in the East.

right: The ball and claw chair is a 50s item bought from a thrift shop and re-covered with a leopard-print fabricskin, because the ornate design suits an outrageous print. The screen in front of the fireplace was bought by Marianne Fassler because she loves handmade craft. The beaded curtain behind the chair is made from Yoruba trade beads. The Yoruba tribe from Ghana, in Africa, are famous for their use of beads, and this colourful rainbow curtain is a delightful, and quite rare, example.

French

I think that there is no more enduring a look in twenty-first-century decorating than French country. It's the most permanently evergreen of all country interiors — as a style it has lasted so well and still looks so fresh and enticing.

For me, French country evokes the colours, patterns, and food of Provence and the south of France. I love the toiles, the wonderful rich quilts and the checks, stripes, and mattress tickings that seem to have faded beautifully under the hot sun. And while you can find lovely blues and greens in this look, there is something about raspberry red that absolutely typifies it. French country, to me, is based on the colours of French food — the chiles, tomatoes, pomegranates, and cherries of a long, hot summer day. Add comfortable, elegant furniture, a jug of wine, and relax into the memories.

Sample board painted by Marinella Angelini and Maria Pia.

country

Of all the patterns found in the French country look, the toiles de Jouy have to be everyone's favourite. In fact, these toiles originated in England and Ireland, but were soon adopted and developed by the French until they became synonymous with French style. This is why you will find some toiles described as English and others as French. Although they are subtly different, either will be perfect for this country look.

Christopher Moore, who designed the rooms shown on many of these pages, is an international toile expert, buying antique eighteenth- and nineteenth-century fabrics and reproducing their patterns authentically (seen top right and bottom left on this page). His shop at Nicole Fabre, London, is a treasure trove of toiles, and a good place to see how the different patterns work together. He suggests adopting one of two different approaches to working with toiles: either to be utterly French and cover everything with toile, in the same colour range (for example, reds and pinks,) or to use a single toile in a room as an accent, covering a chair or for curtains, for example.

Toiles also work well with other French country patterns, such as checks, stripes, and mattress tickings, but it probably looks best if you keep to one broad colour range, such as reds and pinks. It takes a very expert eye to make different coloured toiles work together in a room.

The French country look, with its piles of cushions and quilts, is particularly appealing in bedrooms, where it can be teamed with beautiful beds: bateau lit, four posters, or traditionally dressed in the French style with a sweeping corona of fabric flowing from the wall above.

You can either leave rooms simple and bare in French farmhouse style, allowing the patina of the wood and the pattern of the fabric to be the only decoration, or you can add romantic touches; use chandeliers, faded Rococo mirrors, or a delicate love-seat sofa for an atmosphere reminiscent of a château.

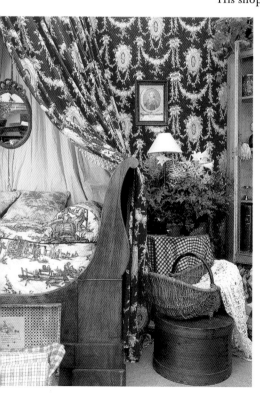

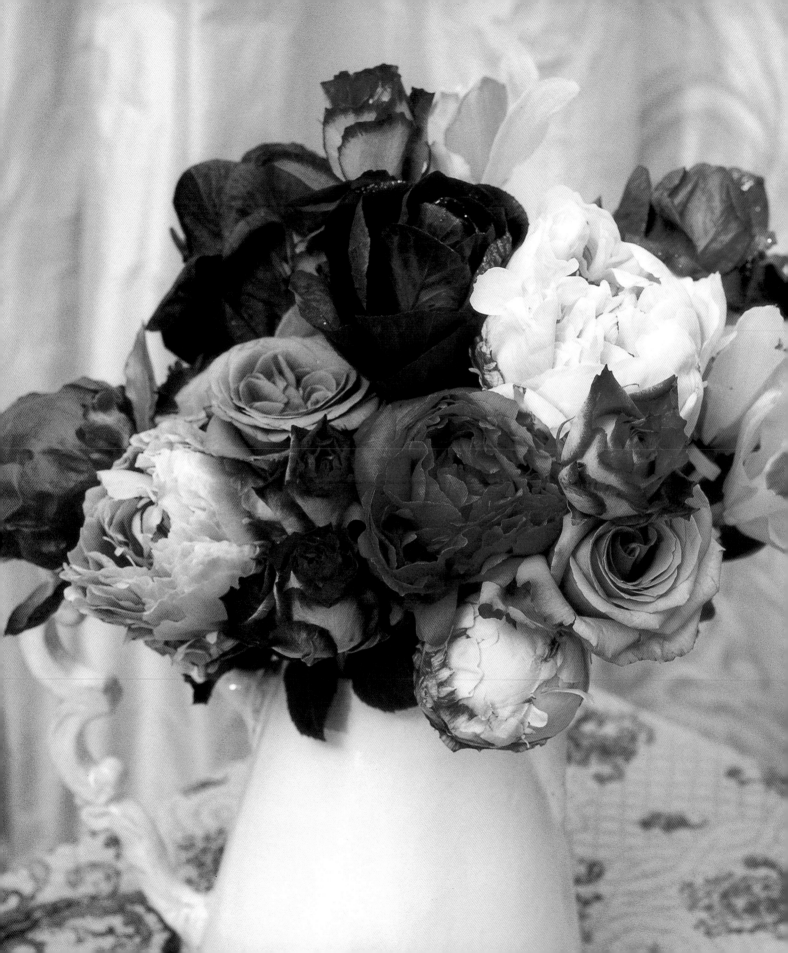

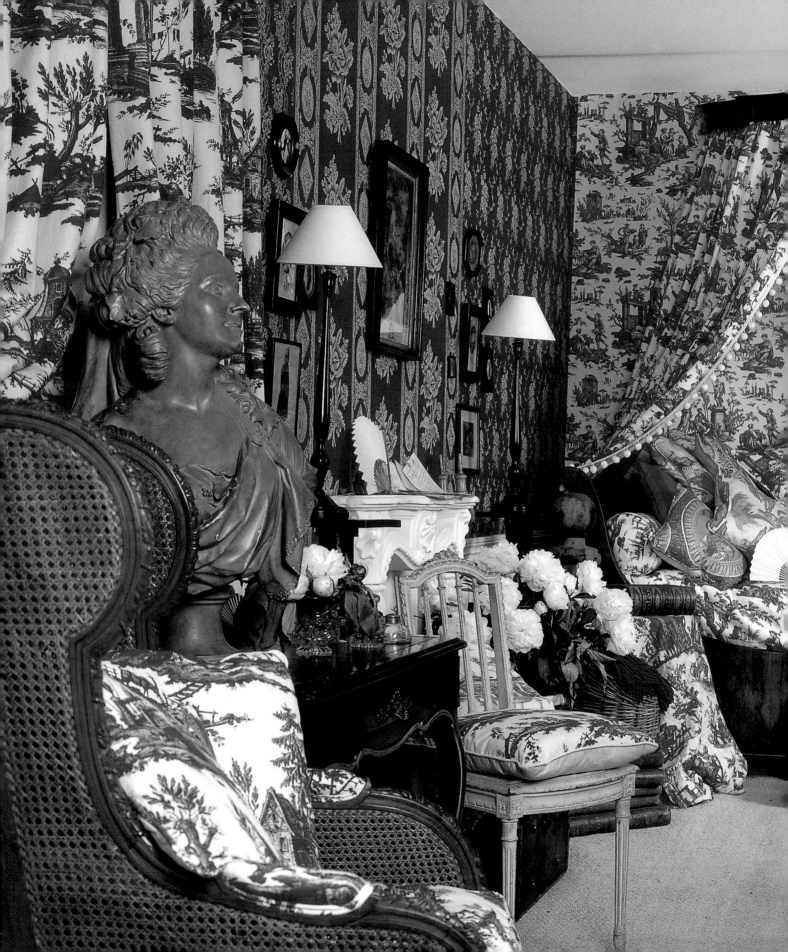

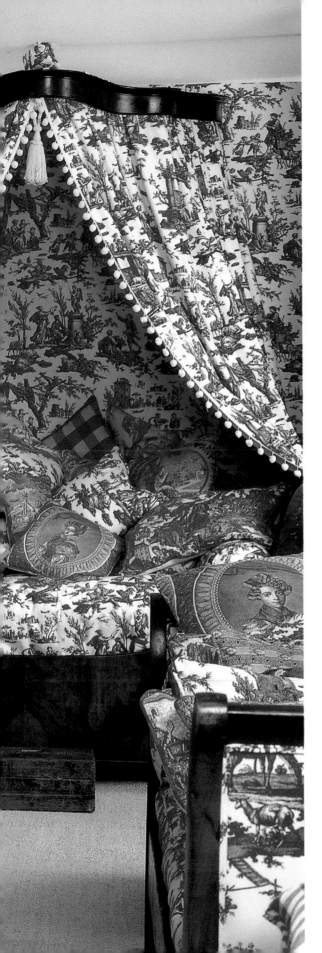

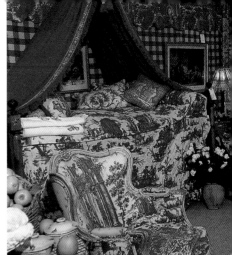

toile

left: This room is decorated in Christopher Moore's handblocked toile wallpaper and fabric reproductions of original 18th-century French patterns: "L'Offrande a L'Amour" and "Rousseau."

above: Another room by Moore shows how well toiles work with checks. The bed is dressed in a traditional French style with canopied hangings.

You really can't go wrong with this kind of French country look — it's not only one of the most attractive and long-lasting styles around today, but it's very easy to achieve. These toiles, from toile expert Christopher Moore, are piled one on top of the other with wallpapers, bed hangings, and cushions in several antique toile patterns, but as they are all reds, there's no worry about clashing. A completely toile room is stunningly romantic, yet also cozy and welcoming.

interiors

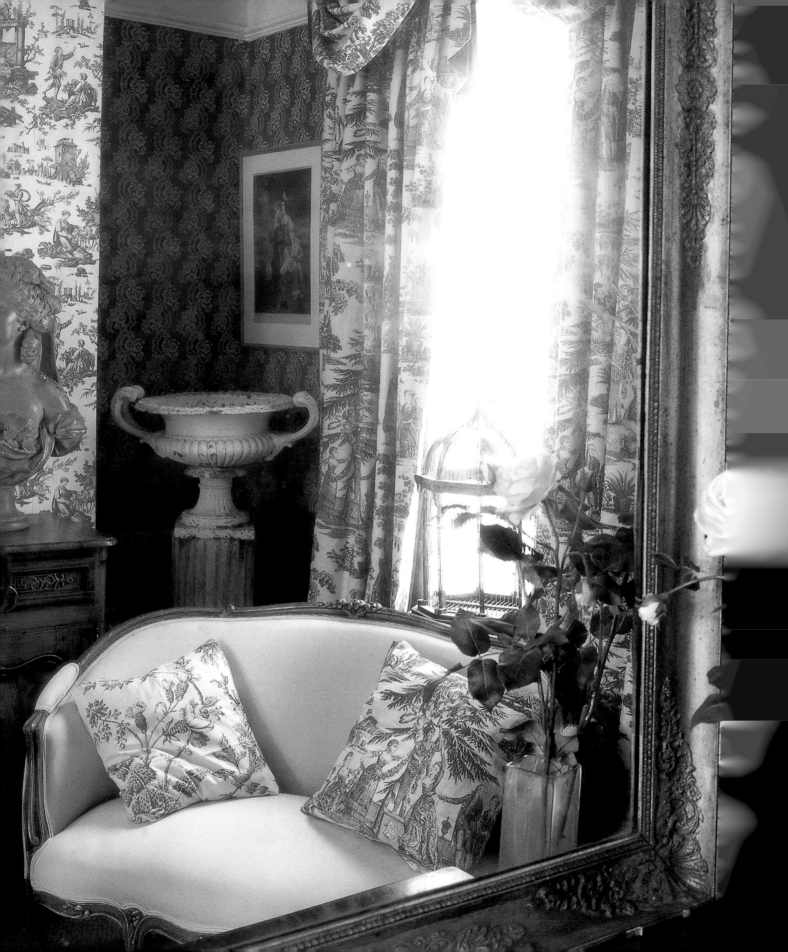

French
romance

Here a light, but romantic, use of toile combines it with checks or uses it on walls and in curtains, while keeping the rest of the room quite simple. This slightly restrained approach is ideal for sitting rooms, while the "toile everywhere" style suits bedrooms best.

Prettiness is the key: a delicately shaped white sofa, an antique birdcage or a garden urn evoke images of summer love and the feeling of sunshine outside. Decaying grandeur works well with this look — the garden urn is slightly rusted — so you don't have to restore or repaint old items. The toiles and checks on this page are from Christopher Moore.

left: The check wallpaper, called Kelsch, is taken from a original French pattern from Alsace.

above: Red toiles look good together with reversed backgrounds, as seen here with Christopher Moore's reproductions of the 18th-century Damask collection.

far left: The curtains are King George III toile reproduced from an 18th-century original and the walls are covered in a handblocked wallpaper named "Crecy."

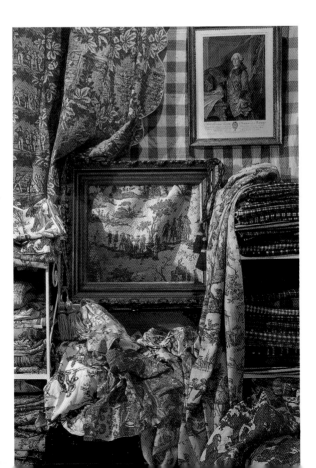

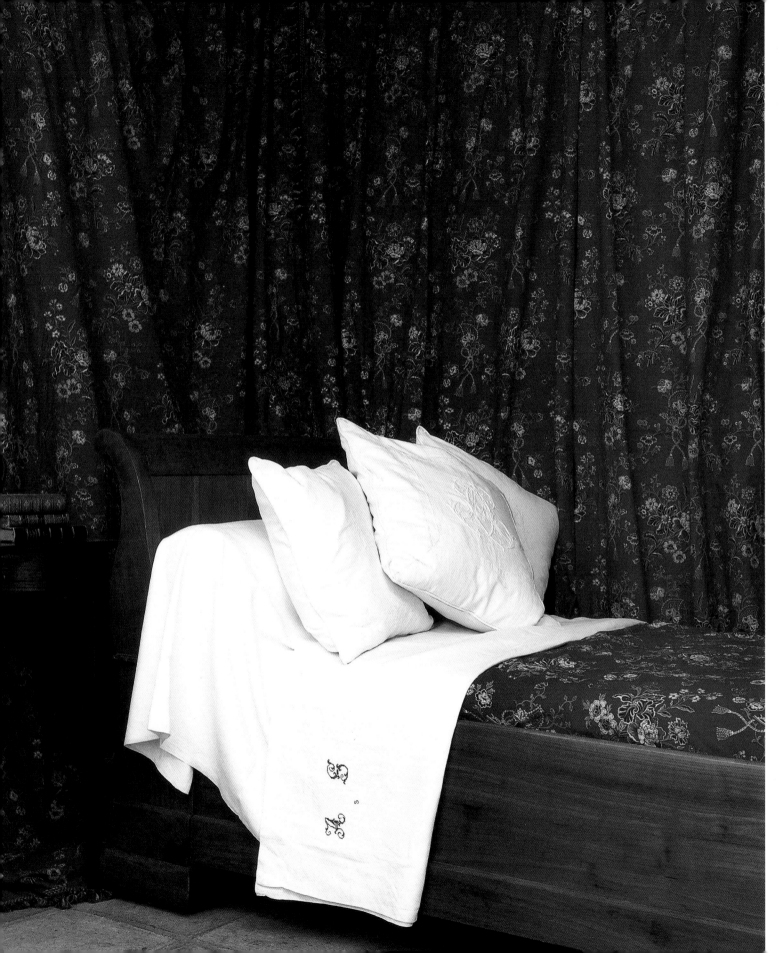

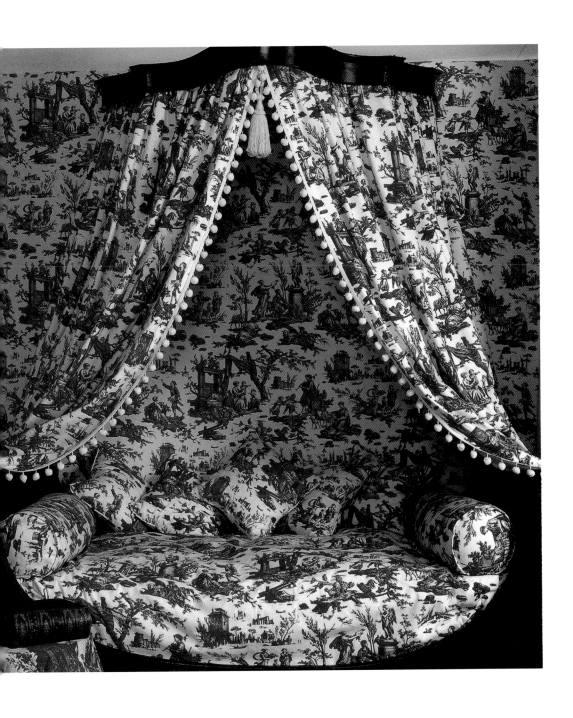

far left: This cheerful French country fabric isn't a toile but a tomato-coloured Provençal fabric. It has a rustic simplicity and is perfect for bedrooms.

left: Toile expert Christopher Moore demonstrates the traditional way to dress a French country daybed, with bolster cushions at either end and a canopy of matching fabric hanging from the wall.

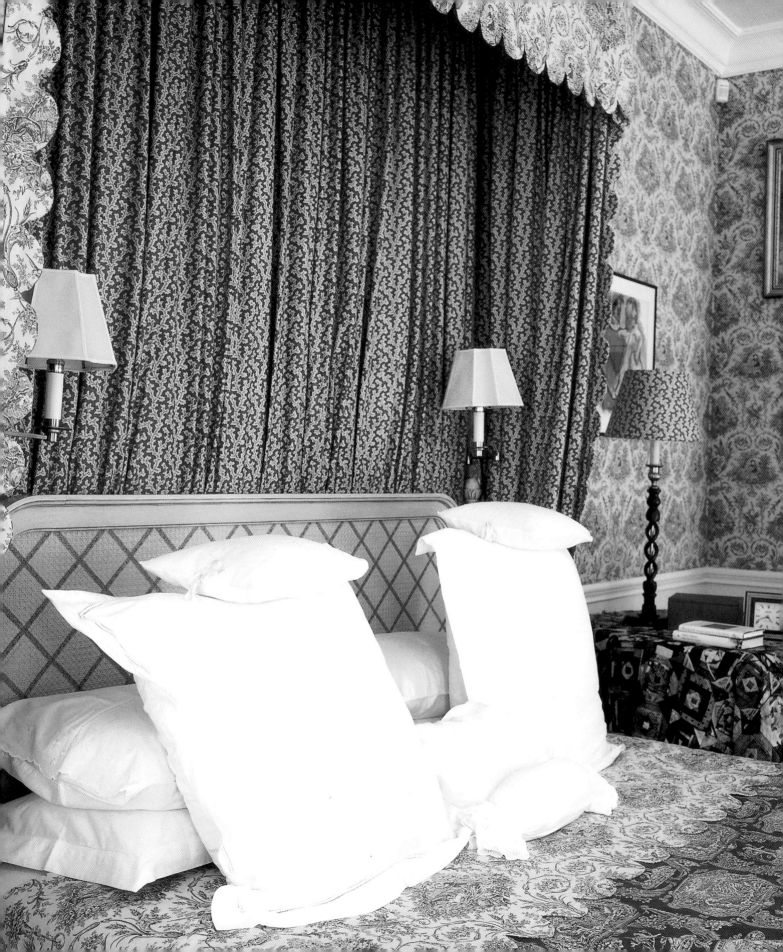

country
chic

I *love* stripes and checks with toiles – I think it

is one of the most chic and stylish country

looks that you can do, and it's not difficult to

achieve if you keep to one colour, such as red,

as Liz Fallon has done in this bedroom.

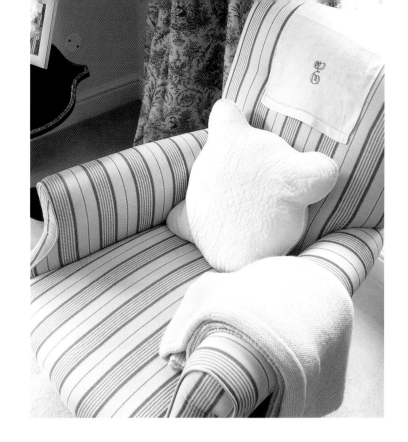

far left, left and above:
In this country-style
bedroom Liz has cleverly
used three different
toiles in shades of red on
her bed and canopy and
has flanked it with stripes
and checks on the chair
and the headboard. It's a
sophisticated version of
French country and one
that would look
marvelous in any kind
of home.

classic
country

This is a pared-down French country look

that relies on rich wood rather than fabric for

its impact. To a plain whitewashed room add

just one or two big, quite ornate pieces, such

as this magnificent nineteenth-century

rosewood four poster bed, polished to show

up the wood and left bare of any dressings.

left: The sheets are antique linen, coloured with natural vegetable dyes by Guinevere in London, staining them a soft, welcoming red. The cushions are also made from antique textiles.

right: The 19th-century rosewood four-poster bed is dressed with a 19th-century French counterpane. A 19th-century Dutch tortoiseshell mirror with an ebonized ripple surround sits on a Tibetan chest with floral painted panels. All the antiques are from Guinevere.

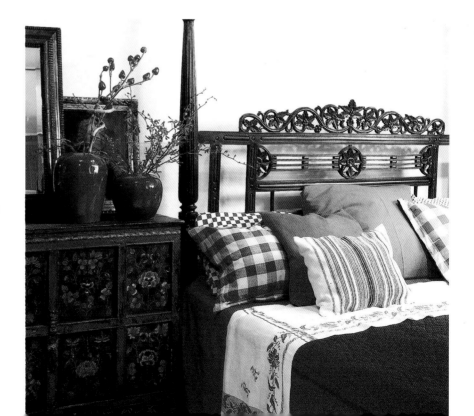

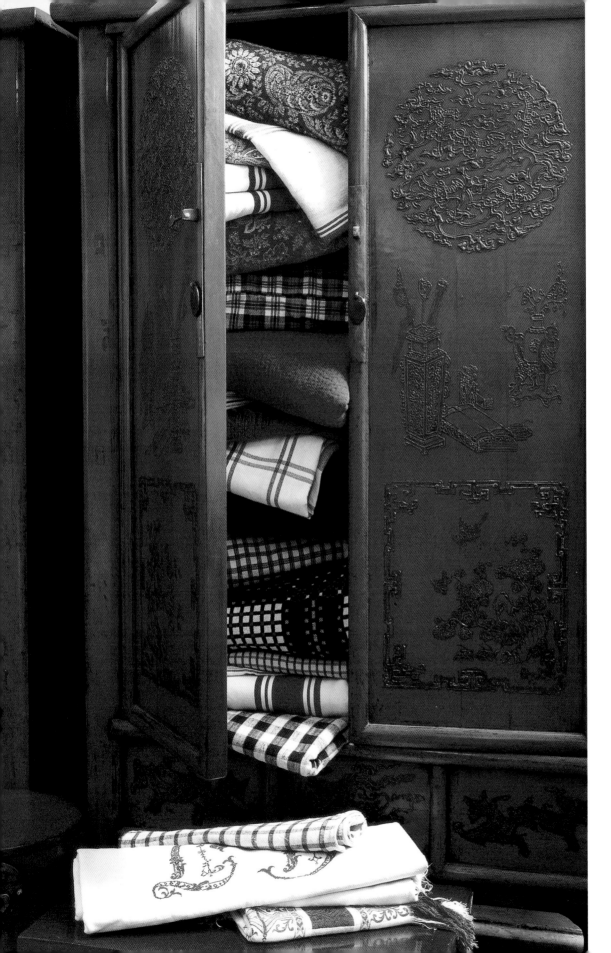

left: French country style
is more about atmosphere
than about using a
particular type or age
of furniture. Here a
Chinese wardrobe filled
with early 20th-century
checked linens fits the
feel perfectly.

right: Antique linen
bags filled with lavender
by Guinevere Antiques
evoke the lavender fields
of Provence. An
embroidered initial adds
a personal touch.

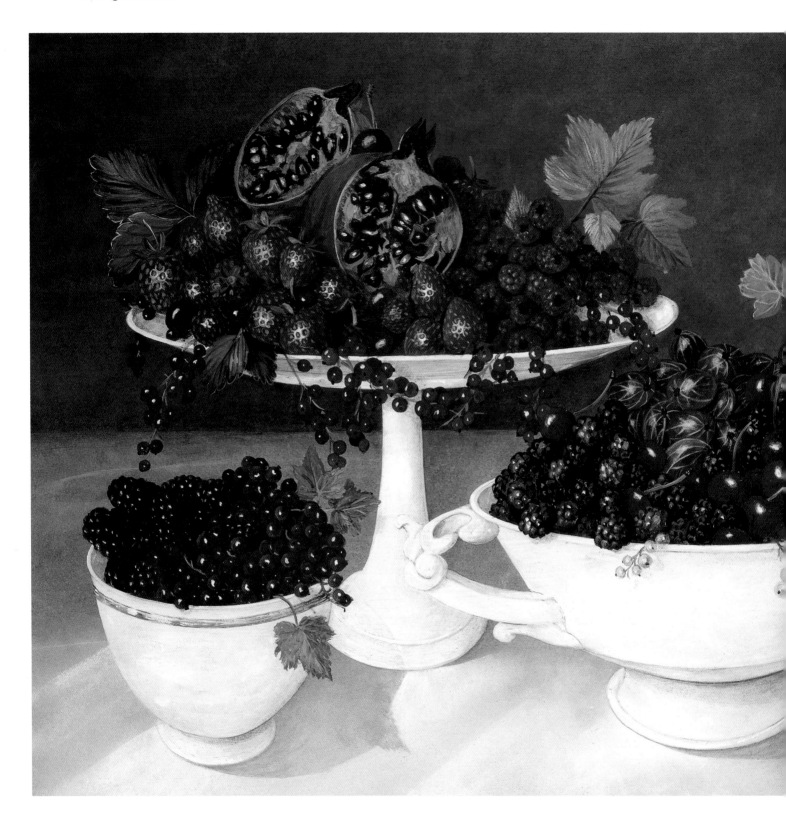

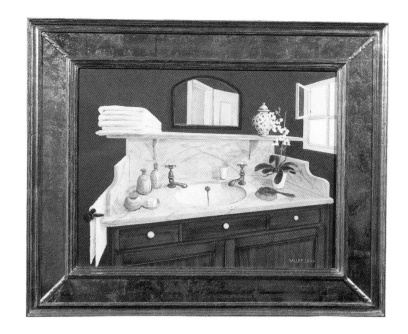

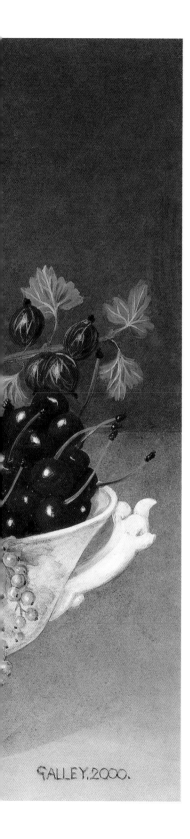

above: This oil on panel by
the artist Galley, is named
Marble Bath, and as well
as being a lovely picture to
hang on the wall, you could
also use it as the starting
point for decorating your
bathroom.

left: This painting, also
by Galley, is a classical
example of a glorious
red painting – the richness
of the berries could offer
a splash of red in a neutral
or white room, or it could
also create a rich, layered
effect in a room mainly
decorated in red.

get
the look

On the following pages I'll share some of my best interior
decoration tips and tricks to help you make the most of
decorating with red. We'll be looking at how to hang pictures,
display collections, and arrange flowers with the expert advice of
imaginative florist Annie Khan. Annie will show you how to
achieve stunning impact, including combining clashing colours
and using tropical leaves to add a chic, modern look to
bouquets. Annie's flowers always last for weeks, so her advice on
flowers is to be taken seriously. All the pictures shown here are
available from my shop, the Stephanie Hoppen Gallery in
Walton Street, London.

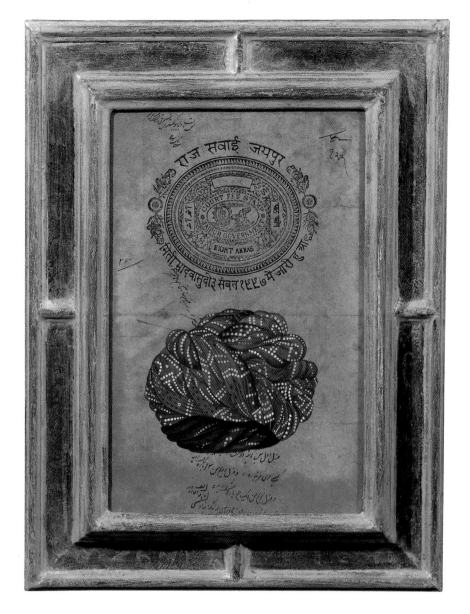

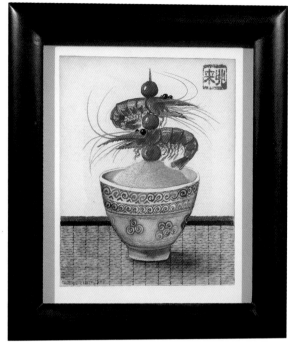

left Turban, a modern gouache and watercolour of an Indian turban on old document paper from Jaipur in hand-crafted frames. Both black and gold are very good frame colours for red rooms. Graphic pictures like this look stunning hung as a series in a regimental manner – a relatively inexpensive way of adding some drama to a room.

decorating
with pictures

Red walls make an absolutely fantastic

backdrop on which to hang pictures, either in

classic, opulent, or modern rooms (for red as

a backdrop to modern paintings see Axel

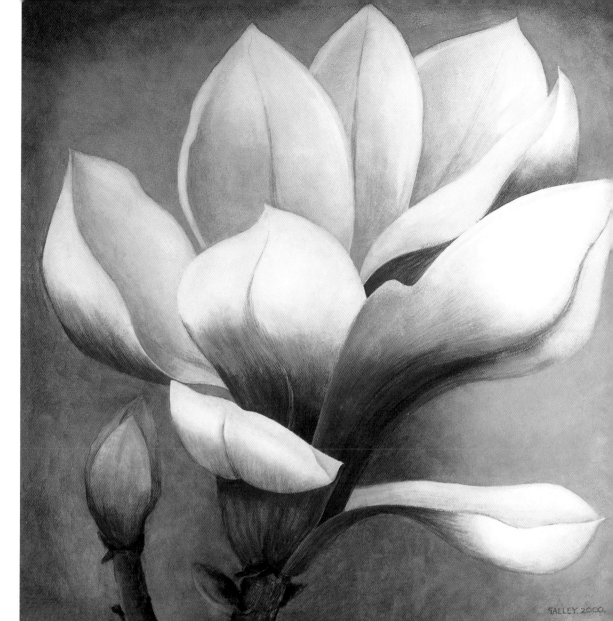

left *Cuisine Chinois, les Crevettes* is a watercolour and collage by Parisian artist, Michel Lablais, who is inspired by his Asian travels to combine food and oriental images with Western themes. He often uses rice or spices in his images.

right: *Magnolia Blossom*, a stunning but simple oil on panel by Galley, would work in either a modern or traditional setting. Leave it unframed for a contemporary effect or use a traditional gold frame against red walls.

Vervoordt's showroom on pp. 22–25.) While modern paintings are often effectively hung unframed, think carefully about framing in more traditional red rooms. I always think that gold works particularly well.

Red paintings can be hung in red rooms, but they are also a brilliant way of introducing colour into neutral or plain rooms too.

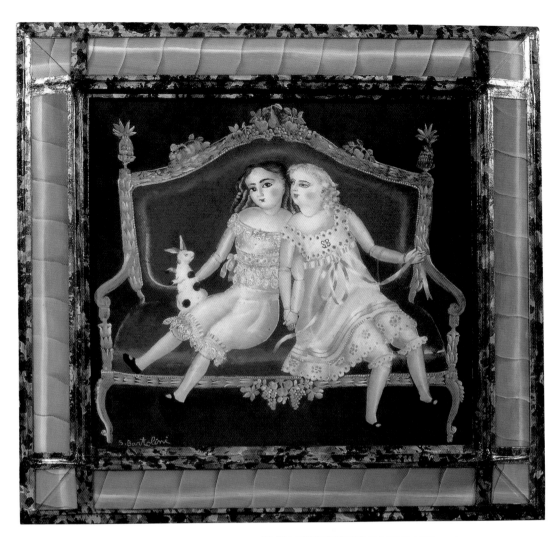

left: *Les Deux Bavois*: this eglamise (a reverse painting on glass) is by French artist Suzy Bartolini, who also painted the frame black, creating an effect like polished agate. Glass paintings add a jewel-like quality to red rooms.

right: *Pink Bathroom* is a modern round watercolour by American artist David Connell of a pink-themed bathroom. Although this painting is contemporary, I wouldn't hesitate to give it a sumptuous treatment, such as a hand-carved gesso and gold-leaf frame, which would look wonderful against red.

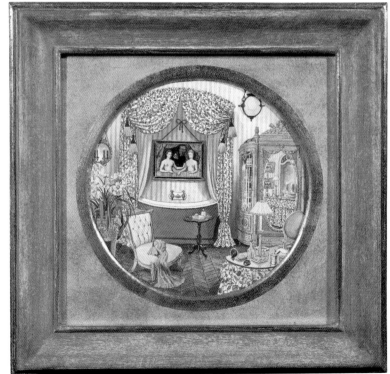

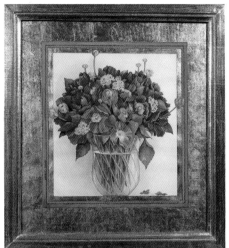

above: *Poppies,* in a
watercolour and gold leaf by
artist Nhaid Aryan Ghodsi is
a perfect blending of
Persian culture and Western
influences. This picture
would work in a traditional,
romantic or opulent room.

right: When hanging
paintings on a busy
background, such as this
raspberry toile de Jouy
wallpaper, pick strong,
simple outlines and images
such as the three-
dimensional sculptural
paintings of trees by Italian
Patrizia Medial.

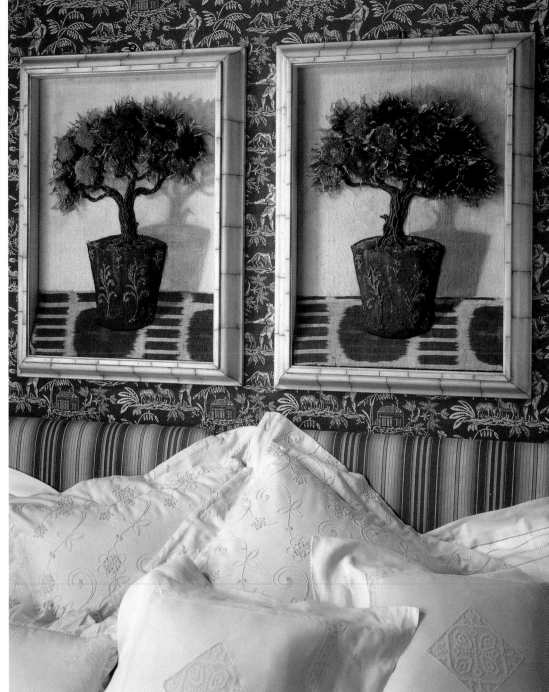

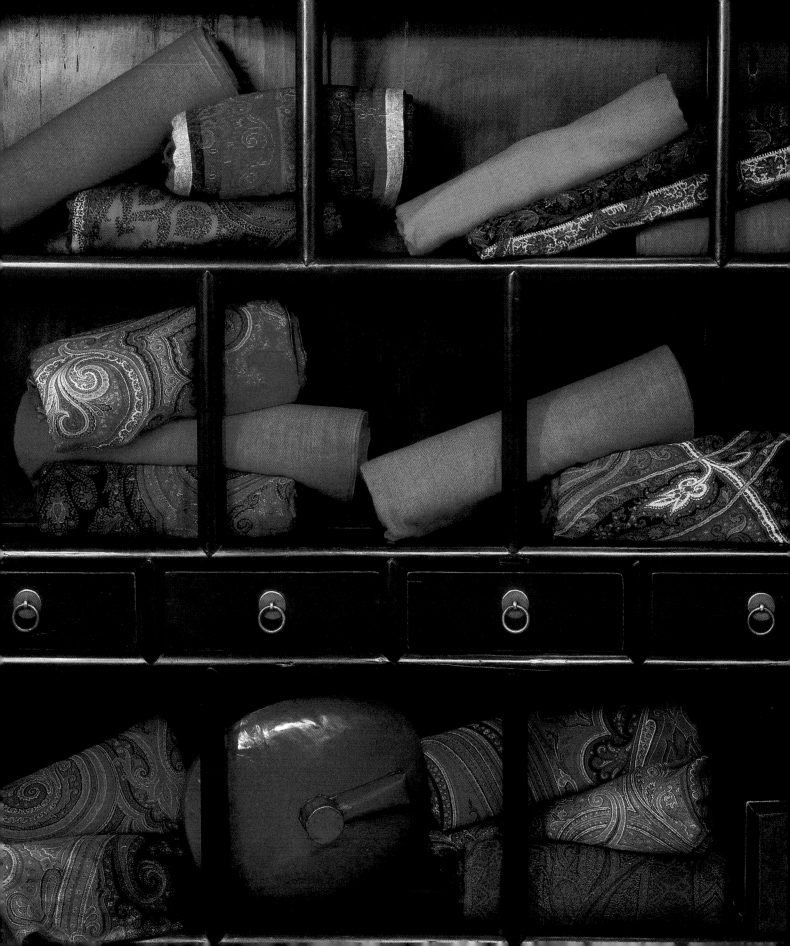

textiles
and textures

There's no need to hide away spare bedlinens, cushions, and tablecloths. You could use an open display technique to show off favourite collections of fabrics, cushions, place mats, and tablecloths while you're not using them. You don't need an antique chest, you could adapt the technique using open shelving from a hardware store or mainstream furniture store.

All these linens come from Guinevere Antiques in London and many are antiques that have been dyed to those lovely old faded shades by the use of traditional natural vegetable dyes. This is a process that Guinevere has perfected to give its linens an authentic aged look.

Bookcases such as this lacquered Chinese chest can be used to display not only books and ornaments, but the textures of your favourite domestic textiles.

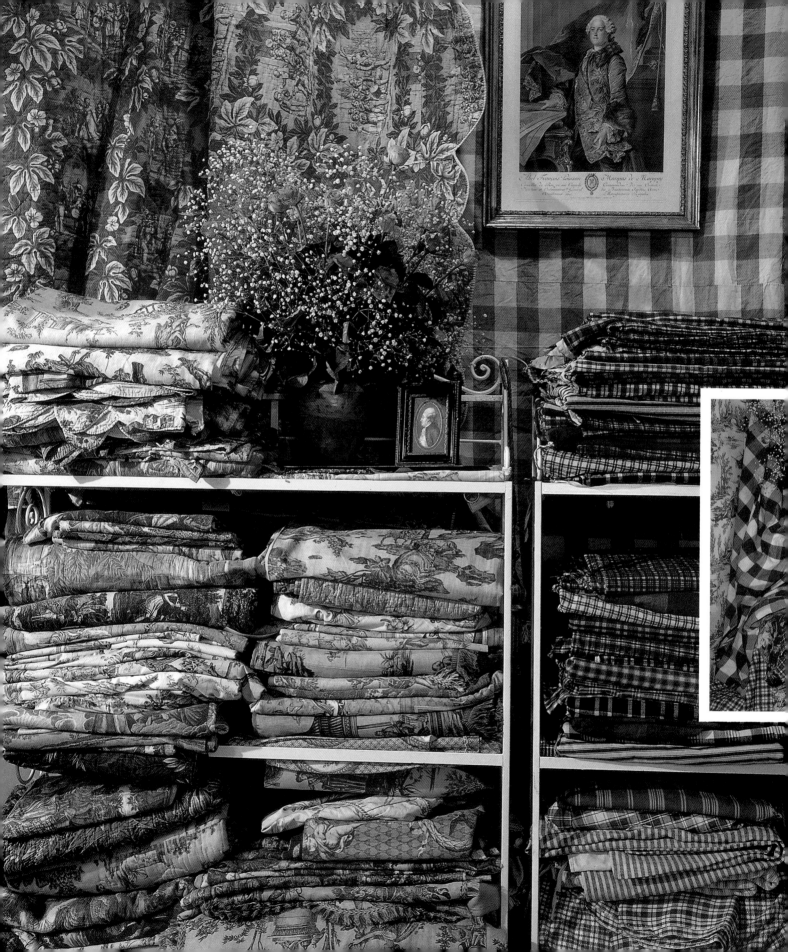

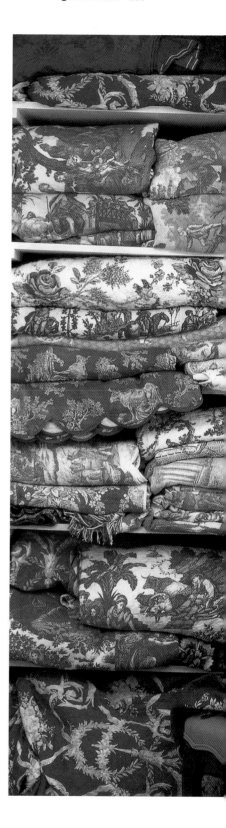

left and far right: The open shelves in Christopher Moore's basement instantly re-create the charm of an old French farmhouse or chateau.

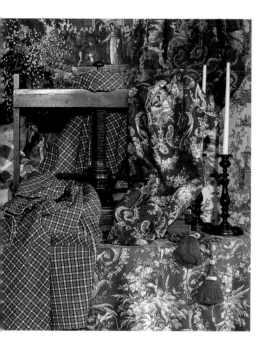

above: You can mix big checks, smaller checks and toiles for a stunning effect.

Christopher Moore's basement shop at Nicole Fabre on London's King's Road is a charming education in how to combine patterns. Layer after layer of enchanting toiles demonstrate how nothing needs to match yet everything will go together naturally. The trick here is to maintain some cohesion: pick a colour, such as soft red, and let everything else follow. Old reds, new reds, checks, and stripes will all sit together beautifully and you can freshen the look by including one or two predominantly white fabrics. Don't worry about faded patches on antique fabrics.

left: Think about texture when planning the total effect of your room. Often wool, like this one, is perfect for a welcoming or comfortable interior. Wools, velvets, and weaves are all useful for creating this welcoming effect.

left inset: Think about texture for glamorous interiors too. This seductive ostrich skin from Bernie de Le Cuona has all the panache of silk, satin, or suede, but with added interest.

far right: As red is such a strong colour, using different textures helps break it up and makes it less overpowering.

right insets: The effect of light on texture needs to be considered. Cottons and linens (above inset) are daytime fabrics, while richer, deeper textures, such as velvet and suede (below inset), are wonderful in evening rooms.

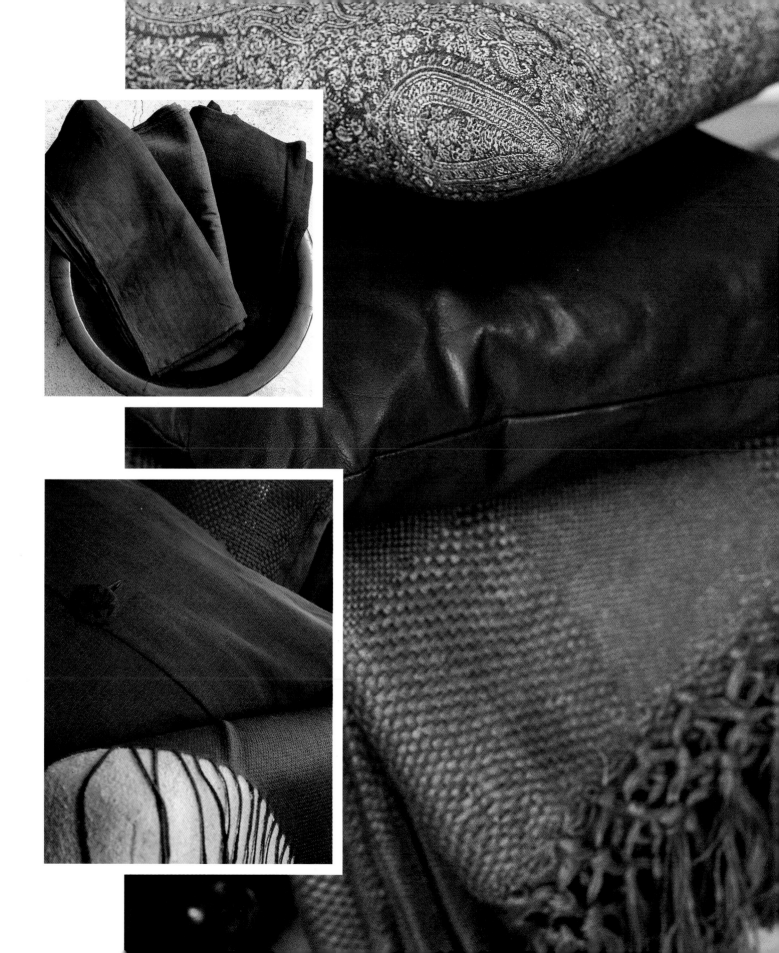

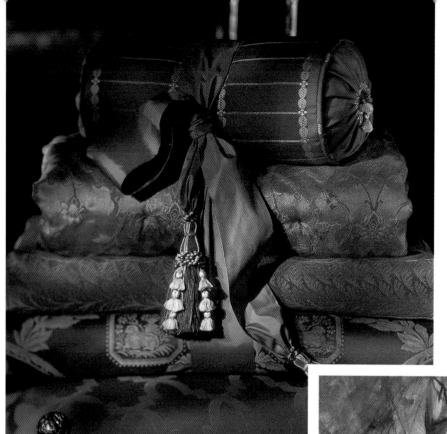

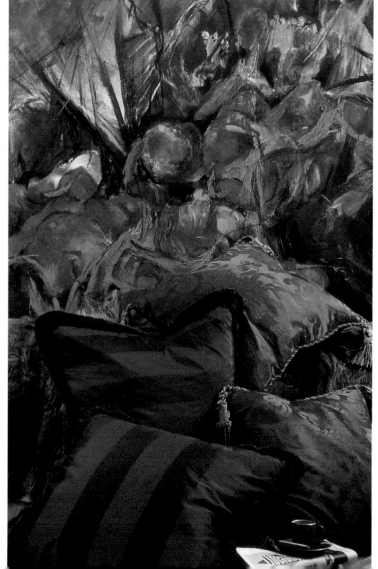

below Vivid pink and red cushions against a strong blue and orange demonstrate the effectiveness of clashing colours in the same depth or intensity – pastels would look wrong in this mix, for example.

above Satins, brocades, damasks, and tassels from the fabric company Schumacher show that when gold is partnered with deep pink the effect is luxurious but not ostentatious.

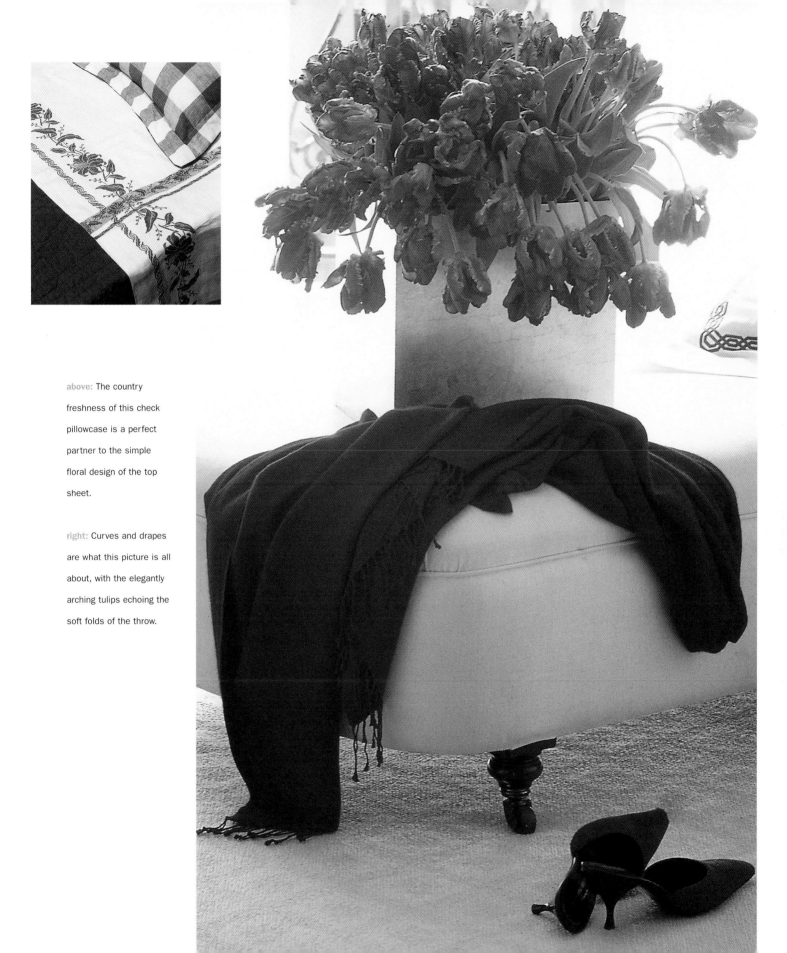

above: The country freshness of this check pillowcase is a perfect partner to the simple floral design of the top sheet.

right: Curves and drapes are what this picture is all about, with the elegantly arching tulips echoing the soft folds of the throw.

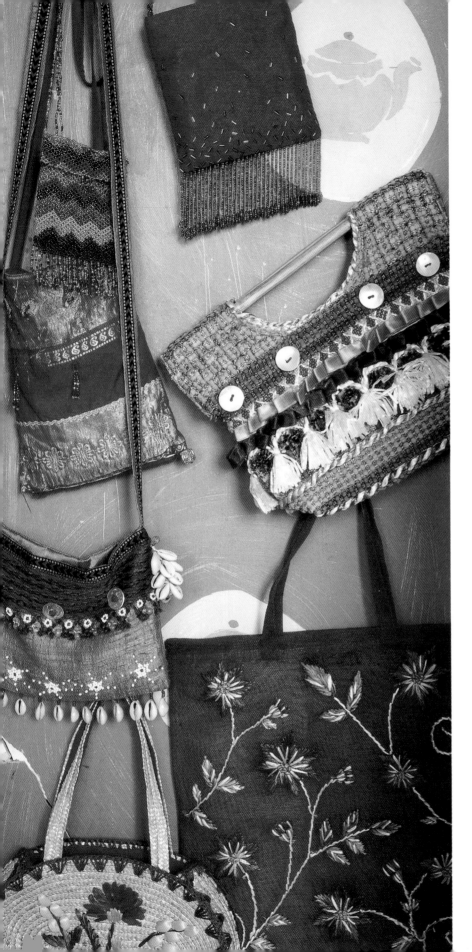

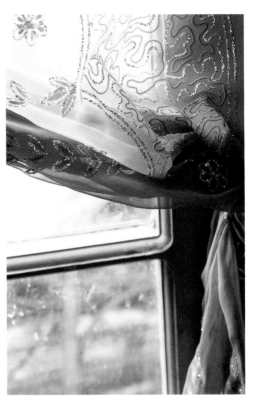

left: I love this effervescent collection of gaily covered bags used as decoration. It's so very "now" yet easy to achieve.

above: The light shining through a sari shows off the delicate tracery of its embroidery.

right: Display your fabulous frocks by keeping them on open rails. It's a contemporary look, and hanging one on a mannequin nearby creates something of the bohemian atmosphere of an atelier on Paris's Left Bank.

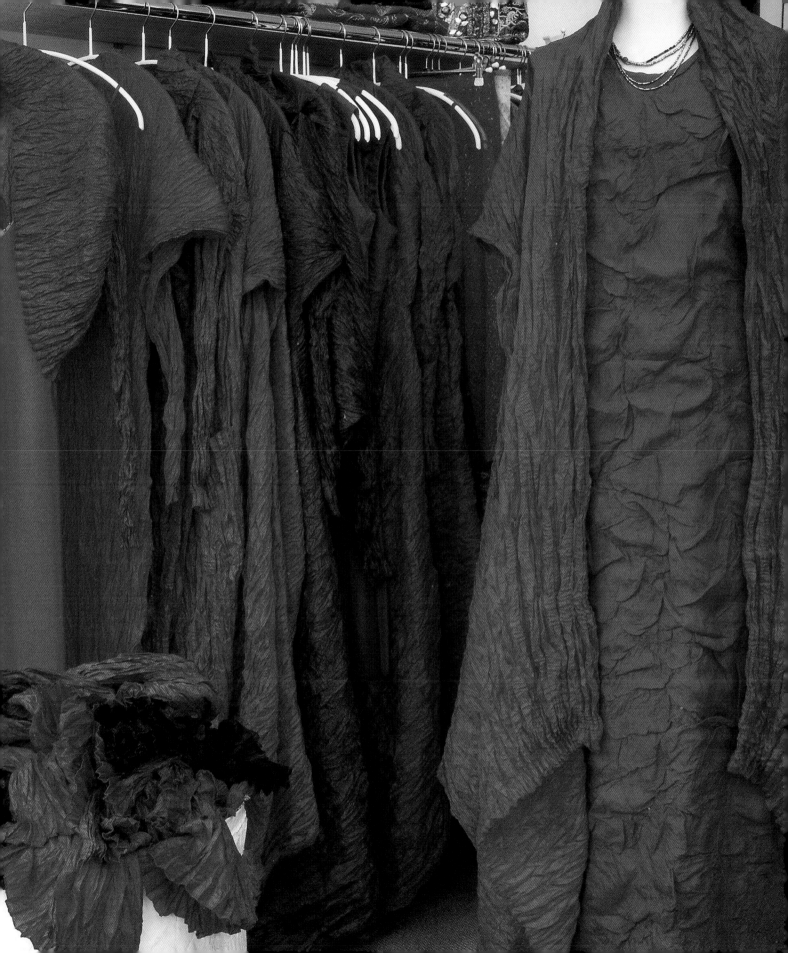

collectables

Collectables are what turn a beautifully designed interior into a real living home. They can be antiques, crafts, or ethnic artifacts and they can be bought, found, or inherited, but what they all have in common is that they reflect the personality of the owner, and they are rarely mass produced.

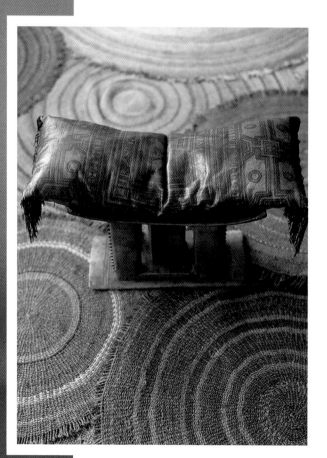

far left and left: It always works to specialize in a genre, such as Steven and Juliette de Combe's collection of South African artifacts. A single magnificent object or focus object makes a stunning display, such as this Tchokwe comb, and the Asanti stool.

right and right inset: For a more cluttered look, combine objects such as these Zulu spoons and earplugs.

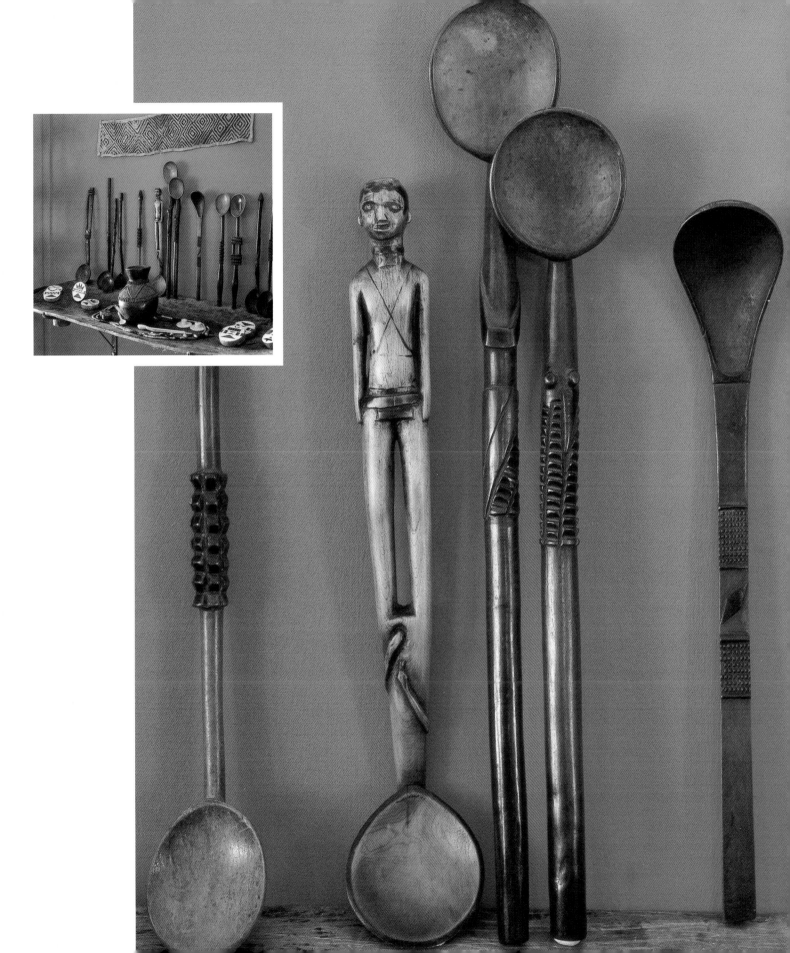

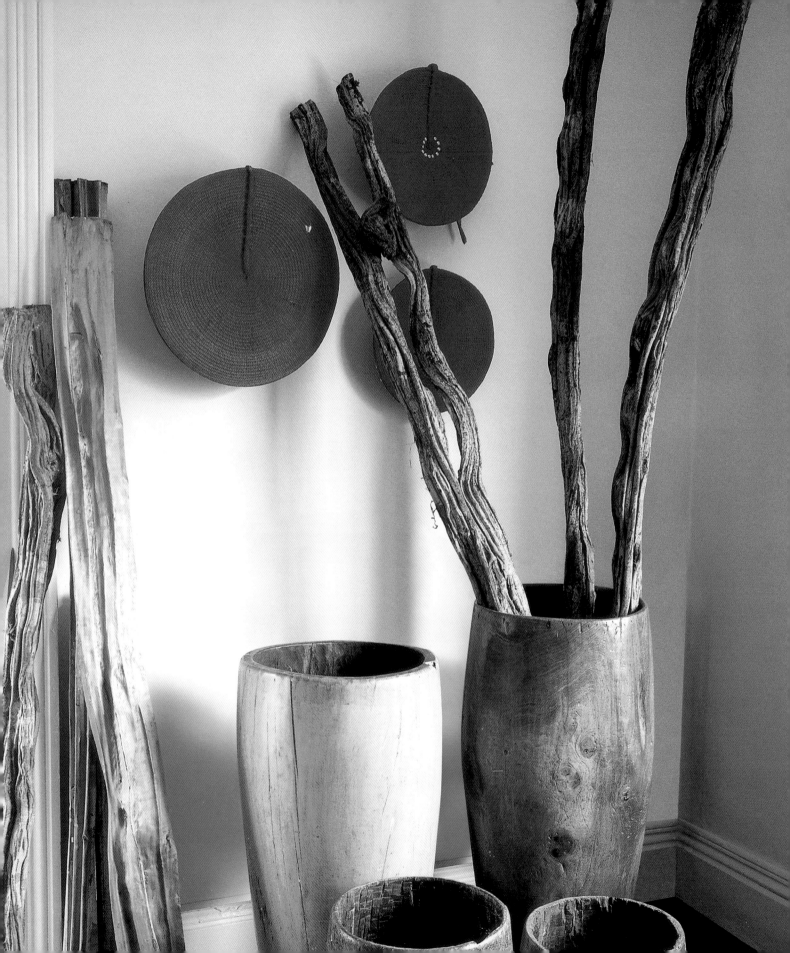

left: One way of displaying a collection is deliberately to contrast shapes, such as these round Zulu marriage hats, smooth pots, and long, thin knobbly staffs.

right: Another successful way to display collections is to keep like with like, such as these lovely *sang-de-boeuf* vases from Guinevere Antiques.

decorating
with food and flowers

I believe that food is now as important a part of decorating your table as the flowers are. There is nothing so effective as displaying them on a beautiful plate. Red food – tomatoes, chilies, apples, and plums, – can look stunning when piled into separate bowls. Don't forget the interesting textures and shapes to be found in vegetables either. Such food need not necessarily be part of your menu but just a tempting little extra for your guests to nibble, or simply a centrepiece.

left: Classic peonies and roses are partnered with more sculptural leaves for a pretty, yet contemporary effect.

right: Florist Annie Khan even managed to find summer luxuries like peonies in the middle of December.

When we gave Annie Khan the task of finding as many amazing, exciting, and inspiring red, pink, and orange flowers as she could in December, her heart must have plummeted, as many of the glorious reds and pinks are summer flowers. However, with her usual talent and enthusiasm Annie somehow managed to fill her shop with wonderful shades of red.

below: Annie Khan creates stunning effects by adding dye to a clear flower vase, but try this out first with just one flower, because sometimes the flowers can take up the colour.

left: A good tip from florist Annie Khan is always to buy flowers in perfect condition, just like these lilies. Any brown tips may mean the flowers have been frozen and may not last.

above: Buy flowers in season, like these spring crocuses and anemones: you'll get much better value for money and they'll be in better condition because they won't have been forced.

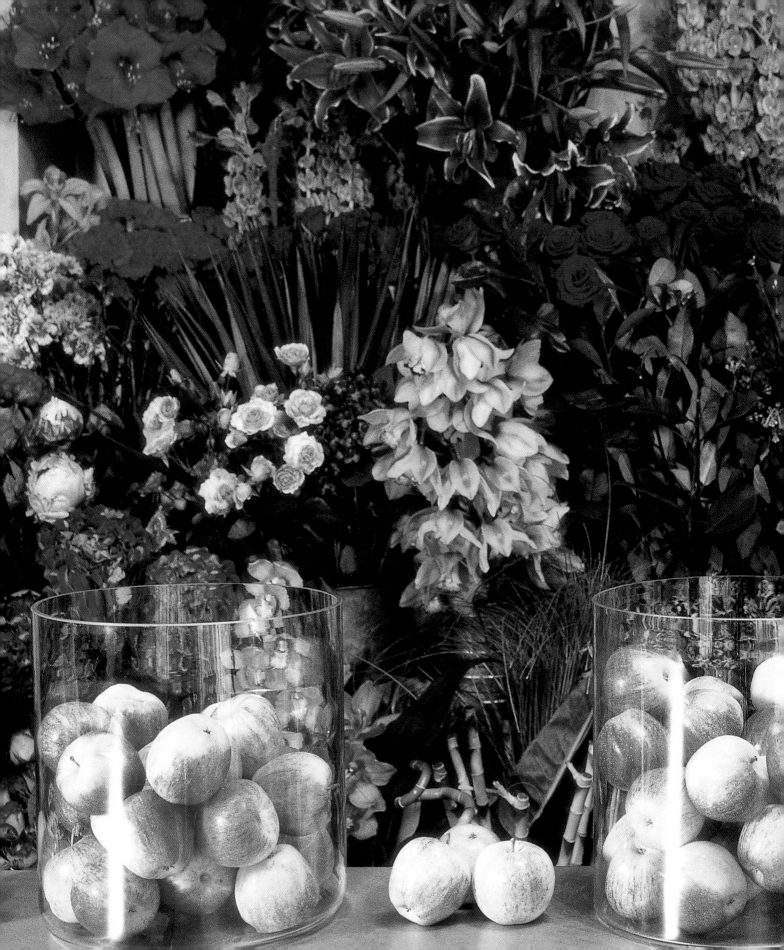

left and below: The wall of Annie Khan's shop was smothered with red, pink, and orange flowers. Note the bowls of red apples. When working with clashing colours, use the same variety of flowers, like these zingy gerbera.

next page: Red food on white dishes forms an amazing red antipasti for a meal. The simplicity of pomegranates in a large wooden bowl epitomizes summer eating.

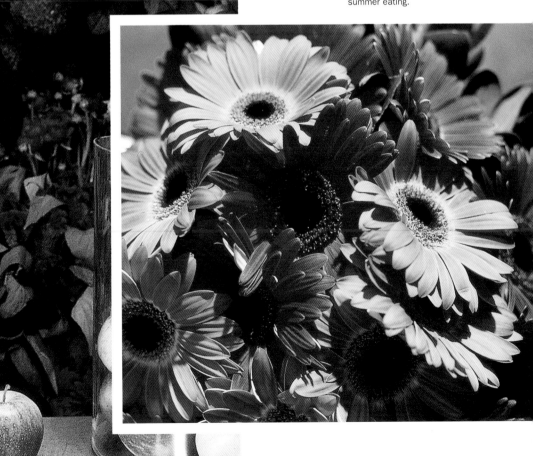

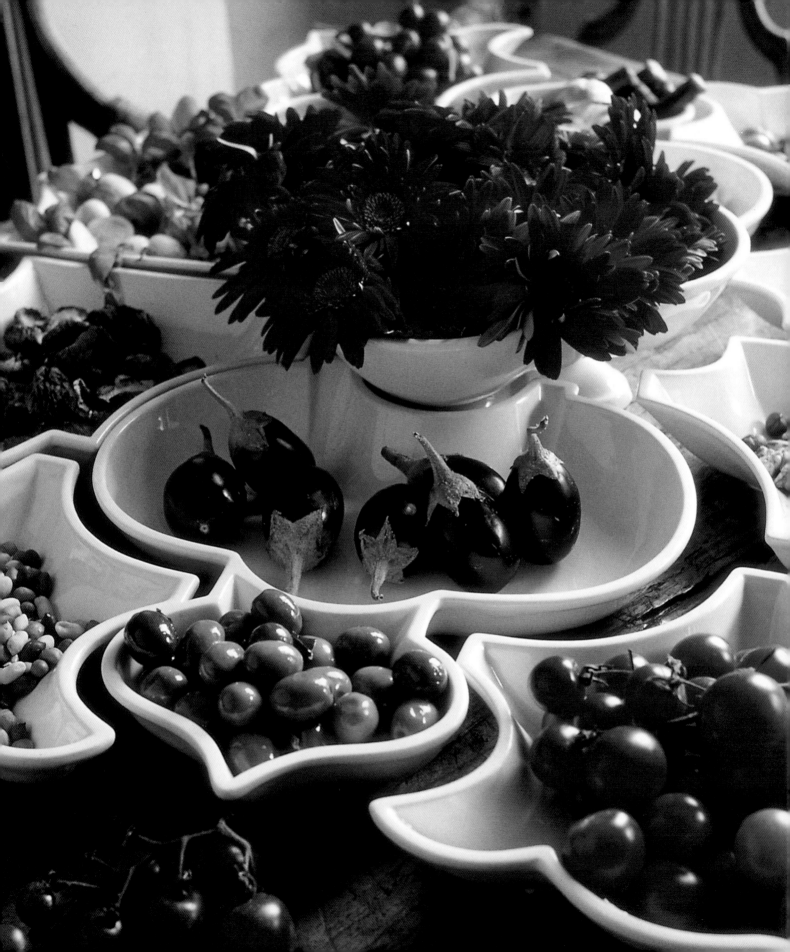

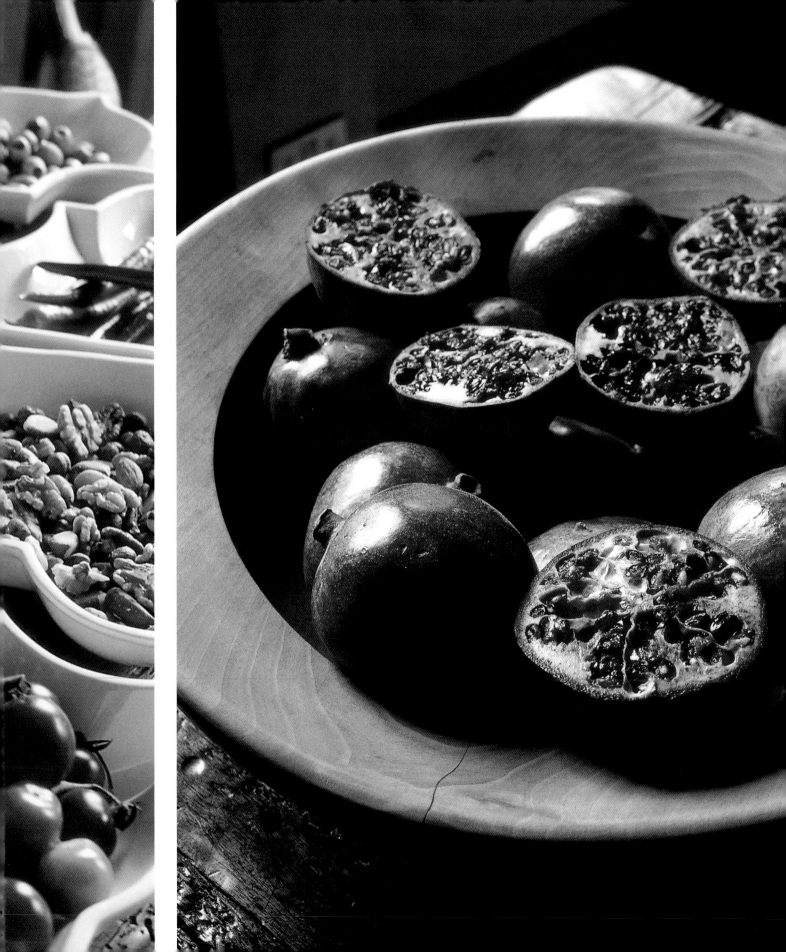

shades of
red

As we have seen throughout this book, the spectrum of red shades and tones is simply breathtaking. A basic understanding of

the different red "families" will help you to use them effectively and with confidence. Here are some of my favourite reds,

which are easy to use and to live with. They are grouped together into colour families to enable you to use and combine the

colours to their best advantage to achieve your desired effect.

orange reds

terracotta reds

red reds

berry reds

pinky reds

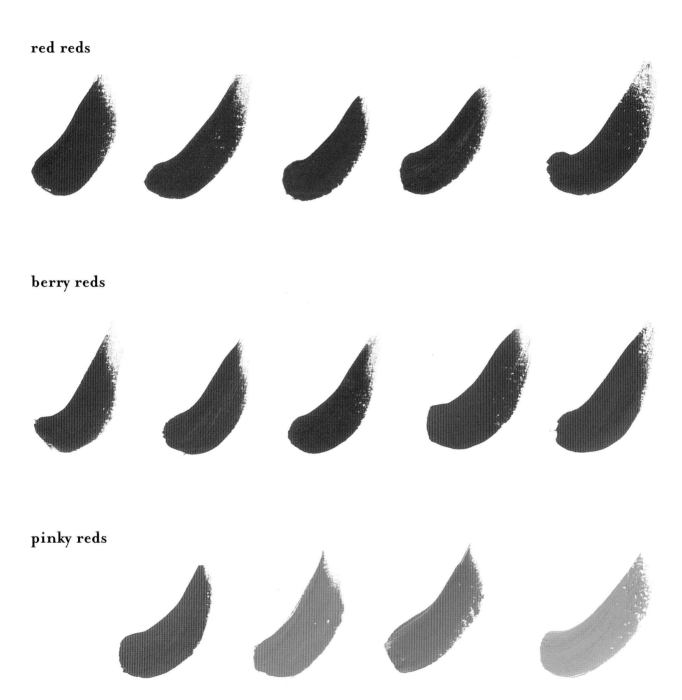

directory of sources

UK

(Telephone numbers include area codes but not national codes.)

decorative antiques

Guinevere Antiques Ltd.
578 Kings Road
London SW6 2DY
Telephone: 020 7736 2917

Kate Bannister Antiques
Angel Arcade
Camden Passage
London N1 8EU
Telephone: 020 7704 6644

Louise Bradley
555 Kings Road
London SW6
Telephone: 020 7751 0881

china, glass, and tableware

Antony Stern Glass
Unit 205-206 Avro House
7 Havelock Terrace
London SW8 4AS
Telephone: 020 7622 9463

Habitat, for branches
Telephone: 020 7

Heals, for branches
Telephone: 020 7

The Conran Shop, for branches
Telephone: 020 7589 7401

flowers

Annie Khan Florist
55 Hatton Garden
London EC1N 8HP
Telephone: 020 7404 4048

Wild at Heart
49a Ledbury Road
London W11 2AA
Telephone: 020 7727 3095

decorative accessories

Louise Bradley
15 Walton Street
London SW3 2HX
Telephone: 020 7589 1442

Nina Campbell
9 Walton Street
London SW3 2JD
Telephone: 020 7225 1011

fabrics

The Monogrammed Linen Shop
168 Walton Street
London SW3 2JL
Telephone: 020 7589 4033

de Le Cuona Fabrics
For stockists
Telephone: 01753 830301

Stuart Hands, curtainmaker
Telephone: 020 7373 0068

Pierre Frey
For stockists worldwide
Telephone: 020 7376 5599

vintage fabrics

Christopher Moore at Nicole Fabre
592 Kings Road
London SW6 2DX
Telephone: 020 7834 3112
and
Christopher Moore's
reproduction toiles available at
Lee Jofa
Telephone: 01202 575457

decorative clothing

Ray Harris
73 Westbourne Park Road
London W2 5QH
Telephone: 020 7221 8052
Opening hours: Mon/Tue. by
appointment only, Wed.–Fri.
1–6pm, Sat. 11am–6pm.

Shari Maryon
For stockists
Telephone: 0117 922 6032

Whistles Ltd.
12-14 St Christopher's Place
London W1U 1NH
Telephone: 020 7486 9008

Butler and Wilson
Telephone: 020 7352 8255

paints

John Oliver
For stockists
Telephone: 0207 221 6466
Paint Library

3 Elystan Street
London SW3 3NT
Telephone: 020 7823 7755

Farrow and Ball
For stockists
Telephone: 01202 876 141

decorative paintings

The Stephanie Hoppen Gallery
17 Walton Street
London SW3 2HX
Telephone: 020 7589 3678

Oriental and ethnic artifacts

Andrew Martin
Telephone: 020 7584 4290

Snapdragon
247 Fulham Road
London Sw3 6HY
Telephone: 020 7376 8889

Selfridges Ltd
400 Oxford Street
London W1A 1AB
Telephone: 0207 629 1234

Linda Bird Ltd
Telephone: 0208940 4001
(by appointment only)

UNITED STATES

The Antique Textile Gallery
PO Box 237196
New York
NY 10023
Telephone: 212 787 0090

Peter Davies
125 Cedar Street
Penhouse
New York
NY 10006
Telephone: 212 732 0273

The Drawing Room
152–154 Spring Street
Newport
Rhode Island 02840
Telephone: 401 841 5061

Michael Fitzsimmons Decorative Arts
311 W. Superior Street
Chicago
Illinois 60610
Telephone: 312 787 0496

Vito Giallo
222 East 83rd Street
New York
NY 10028
Telephone: 212 288 4672
(by appointment only)

Kelter/Malcé
74 Jane Street
New York
NY 10014-1735
Telephone: 212 675 7380
(by appointment only)

The Old Quilt Warehouse
701 East 2nd Street
Wichita, Kansas
KS 67202
Telephone: 800 562 5694

Paula Rubinstein
65 Prince Street
New York
NY 10012
Telephone: 212 966 8954

F. Schumacher & Co.
979 3rd Avenue
New York
NY 10022
Telephone: 212 415 3900

Stephanie Stokes Inc.
Telephone: 212 756 9922

paints

Antique Color Supply, Inc.
PO Box 711
Harvard
MA 01451
Telephone: 617 456 8398

Benjamin Moore
Telephone: 800 826 2623
www.benjaminmoore.com

Bioshield Paint
Eco Design Co.
1365 Rufina Circle
Santa Fe
NM 87505
Telephone: 505 438 3448

Donald Kaufman
Telephone: 201 568 2226

Fine Paints of Europe
PO Box 419
Route 4 West
Woodstock
VT 05091–0419
Telephone: 800 332 1556
www.fine-paints.com

ICI
Telephone: 800 984 5444
www.icipaintstores.com
Janovic/Plaza
30–35 Thomson Avenue
Long Island City
NY 11101
Telephone: 800 772 4381
www.janovic.com

Martha Stewart Everyday Colors
Telephone: 888 627 8429

Old–Fashioned Milk Paint Co.
PO Box 222
436 Main Street
Groton
MA 01450
Telephone: 978 448 6336

Ralph Lauren Paint
Telephone: 800 379 7656

carpets and flooring

ABC Carpet & Home
888 Broadway
New York
NY 10003
Telephone: 212 473 3000
www.abchome.com

Amtico Studio
6480 Roswell Road
Atlanta
GA 30328
www.amtico.com

Ann Sacks Tile & Stone, Inc.
Telephone: 800 278 8453
www.annsacks.com

Carpetmax Flooring Center
Telephone: 800 435 6677

Country Floors, Inc. (2 locations)
15 East 16th Street
New York
NY 10003
Telephone: 212 627 8300

Dal–Tile Corp.
Telephone: 800 933 TILE
www.daltile.com

Kentucky Wood Floors
Box 33276
Louisville
KY 40232
Telephone: 502 451 6024
www.kentuckywood.com

The Rug Barn
234 Industrial Park Road
Abbeville
SC 29620
Telephone: 864 446 3163

furniture and accessories

ABC Carpet & Home
See under Carpets and Flooring

Ad Hoc
136 Wooster Street
New York
NY 10012
Telephone: 212 982 7703
www.adhocny.com

Anthropologie
1801 Walnut Street
Philadelphia
PA 19103
Telephone: 215 568 2114
www.anthropologie.com
Call or see website for stores

California Closets
Telephone: 800 336 9178
www.calclosets.com
Call or see website for stores

The Conran Shop
407 East 59th Street
New York
NY 10022
Telephone: 212 755 9079

Crate & Barrel
650 Madison Avenue
New York
NY 10022
Telephone: 212 308 0011
www.crateandbarrel.com
Call 800 323 5461 or see website
for other stores
Mail order:
PO Box 9059
Wheeling
IL 60090

Hold Everything
Telephone: 800 421 2264
www.holdeverything.com
Call or see website for stores
Mail order:
PO Box 7807
San Francisco
CA 94120

Hollyhock
214 North Larchmont Boulevard
Los Angeles

CA 90004
Telephone: 323 931 3400

IKEA
Telephone: 800 434 IKEA
www.ikea-usa.com
Call or see website for stores

Lloyd/Flanders
PO Box 500
3010 10th Street
Menominee
MI 49858
www.lloydflanders.com
See website for stores

Maine Cottage
PO Box 935
Yarmouth
ME 04096
Telephone: 207 846 1430
www.mainecottage.com

Peter Bentson
Bentson–West
325 Pacific Avenue
San Francisco
CA 94111

The Pottery Barn
2109 Broadway
New York
NY 10023
Telephone: 212 219 2420
www.potterybarn.com
See website for other stores
Mail order:
PO Box 7044
San Francisco
CA 94120-7044
Telephone: 888 799 5176

Restoration Hardware
15 Koch Road, Suite J
Corte Madera
CA 94925
Telephone: 800 762 1005
www.restorationhardware.com
See website for stores

Shabby Chic (3 locations)
93 Greene Street
New York
NY 10012
Telephone: 212 274 9842
and
1013 Montana Avenue
Santa Monica
CA 90403
Telephone: 310 394 1975
and
46 East Superior Street

Chicago
IL 60611-1203
Telephone: 312 649 0080

Smith and Hawken
394 West Broadway
New York
NY 10012
Telephone: 212 925 0687
www.smithandhawken.com
Call (800) 566 4383
or see website for other stores

vintage/reproduction fabrics

Christopher Moore's
reproduction toiles available at
Lee Jofa
Telephone: 516 752 7600.

SOUTH AFRICA

Mario Lucangioli and Ali Dewajee
Muralist
Telephone: 21 4477736

Juliette and Steven de Combes
Dealers in African Art
Telephone/Fax: +27 021 780 1823
email: decombes@mweb.co.za
(by appointment only)

Marianne Fassler
Fashion Designer
Saxonwold
Johannesburg
Telephone/fax: 11 646 8387
email:marianne@leopardfrock.co.za

Beezy Bailey
Artist
Telephone: 21 4245628

First North American Edition

ISBN 0-8212-2748-3

Library of Congress Control Number 2001088798

Bulfinch Press is an imprint and trademark of Little,
Brown and Company (Inc.)

Additional photography: Andreas von Einsiedel, Jacques
Dirand
Text: Alexandra Campbell
Design: Christine Wood

PRINTED IN SINGAPORE

PHOTOGRAPHIC CREDITS
All photography by Violet Fraser except the following:
Andreas von Einsiedel, pages 28, 29.
Jacques Dirand pages 15, 18, 19, 21, 30–31, 32, 36,
104–105, 140 bottom right, 141 right.
The photographs on pages 136 and 137 are reproduced
courtesy of Christopher Moore at Nicole Fabre
The photograph on page 140, top left is reproduced
courtesy of Schumacher.

Betty Boop is a cartoon character created in the 1930s. Her sexy schoolgirl

persona and her popularity has led to many fabulous and highly collectable

items being produced in her shape and form. Here is a wonderful collection

showing a collection of some of the mass of items which have been made.